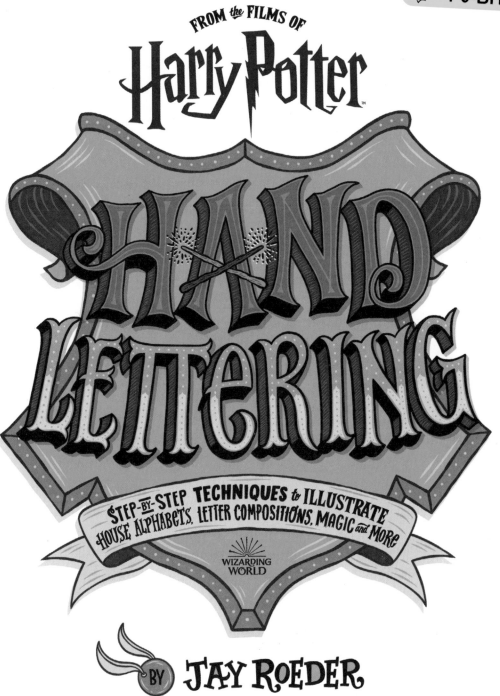

FROM the FILMS OF

Harry Potter

HAND LETTERING

STEP-BY-STEP **TECHNIQUES** to **ILLUSTRATE**
HOUSE ALPHABETS, LETTER COMPOSITIONS, MAGIC and MORE

WIZARDING WORLD

BY **JAY ROEDER**

THUNDER BAY
P·R·E·S·S

San Diego, California

Thunder Bay Press
An imprint of Printers Row Publishing Group
9717 Pacific Heights Blvd., San Diego, CA 92121
www.thunderbaybooks.com · mail@thunderbaybooks.com

Correspondence regarding the content of this book should be sent to Thunder Bay Press, Editorial
Department, at the above address. Author and illustration inquiries should be sent to BlueRed Press Ltd,
31 Follaton, Plymouth Road, Totnes, Devon TQ9 5ND.

Thunder Bay Press
Publisher: Peter Norton
Associate Publisher: Ana Parker
Senior Developmental Editor: April Graham Farr
Developmental Editor: Diane Cain
Editor: Jessica Matteson
Production Team: Rusty von Dyl, Beno Chan, Mimi Oey

Produced by BlueRed Press Ltd.

Author & Illustrator: Jay Roeder

ISBN: 978-1-64517-148-5

Printed in China.

25 24 23 22 21 1 2 3 4 5

For my daughter,

PAYTON AURORA

Always remember that you are

braver than you believe

stronger than you feel

smarter than you think

and

loved more than you would ever know.

CONTENTS

Section 1

INTRODUCTION

If you're reading these pages, chances are you've got an interest in hand lettering *and* Harry Potter. I can't blame you. I've even managed to merge the two passions over the years myself, watching the movies and listening to the audiobooks, while working late nights on various hand-lettering projects.

When I was offered the chance to write a book that merged these two passions together, I was elated. The process of putting this book together has only reignited my interest in the magical universe created by J.K. Rowling. Furthermore, I have grown a new appreciation for the beautiful and illustrative nuances seen throughout the movies, whether it be the decadent crests, seals, beautiful potion labels, or the ornate calligraphic scrolls.

Next time you watch a Harry Potter movie, pay attention to these seemingly small details and I can guarantee that you'll have a newfound appreciation for the creative direction of the films and specifically the unique lettering and illustration work.

Throughout the following pages you'll find tool recommendations, step-by-step processes, tips, techniques, and inspiration to create a wide range of lettering styles and graphical illustrations—all inspired by the Harry Potter movies. Keep in mind, this book teaches in my own playful lettering style, which is just *one* of many different approaches. Follow along with each step, interpret them in your own way, and bring your artistic voice to life.

My intention for this book is to share everything I have learned throughout my career as it pertains to hand lettering while presenting it in an easy-to-understand, four-step process. I'll challenge you to make and embrace your mistakes, step outside of your comfort zone, and try new things, and in doing so, you will become a well-rounded and confident lettering artist. The more effort and practice you put in, the more you will get out of this book—as is the case with most things in life.

Well, what are you waiting for? Put on your favorite Harry Potter movie, grab a quill and some parchment, and start your hand-lettering adventure today!

JAY ROEDER

Section 2
GETTING STARTED

WHAT IS
HAND LETTERING?

Hand lettering is ubiquitous throughout human history. From marketing campaigns to logos or signs on the street, it can be found everywhere, yet it is a term that most people don't understand. In short form, it is the art of drawing letters. Each hand-drawn letter takes on its own individual style and has a specific role within a composition. Lettering can transform a simple message into a beautiful work of art. It is unique and expressive and conveys a natural hand-crafted touch that computer fonts simply can't replicate. Lettering artists use a range of tools to create their artwork, like pens, pencils, markers, brushes & chalk.

Hand lettering is a discipline that takes dedication and practice, but luckily you've come to the right place. Follow along with this section to learn about tools, letter anatomy, and the four-step letter-drawing process, and you'll be hand lettering in no time!

MAGICAL TOOLS OF THE TRADE

Selecting the right tools can be a bit intimidating when you're starting out. Luckily, most of the supplies you'll need are relatively inexpensive. Below, you'll find the essential tools that I use to create hand-lettered artwork. Experiment with a range of tools to find the ones you prefer, and always remember: it's not the tools that make the art—it's the artist.

PENS & PENCILS

There is no better tool for planning a composition than a pen or pencil. When selecting a pencil, find a lead hardness that suits your style. I prefer a softer lead.

ERASERS

Although I prefer to use erasers sparingly, they can be great tools for minor revisions and tweaks.

COLORED PENCILS AND MARKERS

Colored pencils and markers are great tools for colorizing your artwork. Each provides a very different result. Markers are vibrant, with consistent color. Pencils create more of an organic look that show off the artist's strokes. Try both to determine what suits your preference.

PAPER

Experiment with different paper types to find something you like. I prefer tracing paper, as it allows me to trace over my rough sketches.

TABLET AND STYLUS

There are many benefits to using a digital tablet and stylus, especially when it comes to efficiency throughout the lettering process.

ANATOMY OF THE LETTERFORM

Before stepping into the world of hand lettering, it is helpful to have a basic understanding of the anatomy of the letters that make up a given alphabet. Understanding the various parts of a character will allow you to visually deconstruct it and, in turn, make it easier to create your own. Below, you'll find a brief overview of common terminology associated with letterform anatomy.

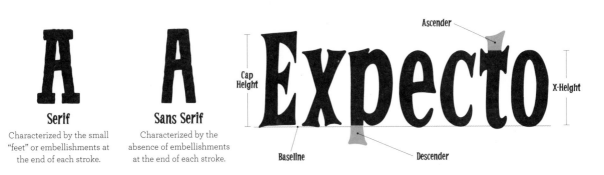

Serif
Characterized by the small "feet" or embellishments at the end of each stroke.

Sans Serif
Characterized by the absence of embellishments at the end of each stroke.

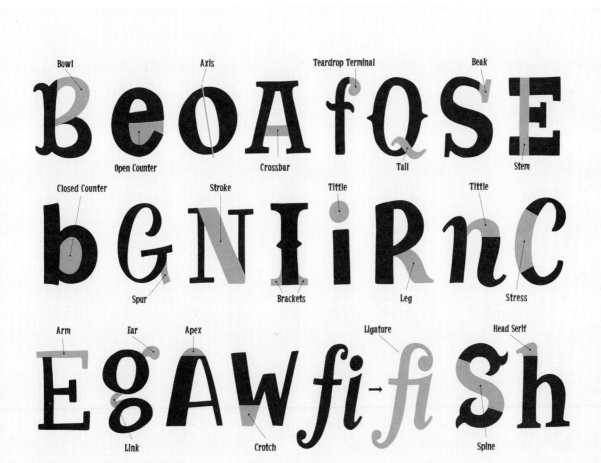

THE HAND-LETTERING PROCESS

Establishing a workflow can be one of the toughest hurdles to overcome. You may have an idea of what you want your finished artwork to look like but don't know how to get there. Over the years I have come up with my own simplified process for hand lettering, distilled down to four easy steps.

MAGIC

① WIREFRAME

When first starting out, it can be tempting to immediately dive into creating the final stage of your artwork. However, it's important to build a solid foundation to get to the finishing line. All of my artwork starts out with a wireframe: this is a simplified line drawing of a letterform. Think of it as a skeleton that will provide the backbone for future steps. Avoid stressing about clean linework at this point.

MAGIC

② ROUGH SKETCH

Once you have a wireframe in place, it's time to roughly sketch out the thickness of each letterform. This is the step where you establish the letter style. Are you going for a serif or sans serif styling? Tall or short lettering? The rough sketch step is very important for identifying style choices that will determine the direction of your lettering art. Keep your linework loose and avoid adding too much detail at this stage.

TIP Don't be afraid ✪ make mistakes along the way. Uneven lines *and* mistakes can add interest to your lettering work. Embrace the imperfections!

MAGIC

③ REFINE SKETCH

Once you have your rough sketch worked out, it's time to refine the lettering in preparation for the final step. At this point I like to clean up the linework and add smaller flourishes and details, like the inline seen above. Refining a sketch can be a bit more time-intensive than earlier steps, but it has a more finished appearance, which can be very rewarding. It's a good idea to take your time and avoid rushing this step.

MAGIC

④ COLORIZE

The tough part is done. You've created a detailed piece of black and white art—now it's time to bring that sketch to life with color. Use a pen or marker to ink the artwork by tracing over your refined sketch. I like to set a piece of tracing paper over my refined sketch so I don't have to worry about erasing any linework from earlier steps. If you're looking to colorize electronically, scan your inked lettering onto a computer.

Section 3
LETTERING AND ILLUSTRATION

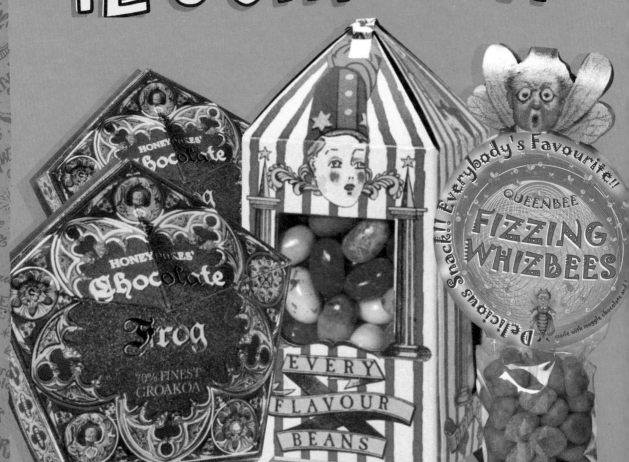

HONEYDUKES' Chocolate Frog
70% FINEST CROAKOA

EVERY FLAVOUR BEANS

Delicious Snack!! Everybody's Favourite!!
QUEENBEE FIZZING WHIZBEES
made with muggle chocolate only

14

INTRODUCTION TO
LETTERING and ILLUSTRATION

Hand lettering on its own is a beautiful craft, but adding smaller graphic illustrations to a lettering composition can sometimes add a fun and dynamic finished effect. Such extra illustrations can greatly enhance a lettering composition, even when they are very simplistic in nature, such as a tattered banner, wand, potion, or cauldron.

In this section you'll learn how to draw some Harry Potter-inspired alphabets and simple illustrations. We'll practice merging lettering and simple illustration and bring everything together into a single balanced composition.

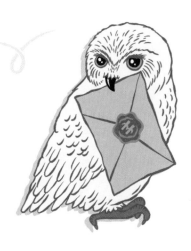

MUGGLE MISCHIEF ALPHABET

This serif alphabet is inspired by lettering seen throughout the movies. It is defined by its quirky and playful appearance. Evaluate the letterforms below, and learn how to draw them from wireframe to full color by following the lettering construction guide below.

A B C D E
F G H I J K
L M N O P
Q R S T U
V W X Y Z

HOW TO DRAW LETTERFORMS

Begin with a basic wireframe. Keep it simple, as it will serve as a guide in future steps.

Visually break the letterform into a series of shapes. Keep this sketch loose. The serifs should be angled and elongated as seen above.

Clean up the letterform to make the final step easier. The finished effect should have clean linework.

Trace over your sketch in dark blue ink. Try adding a lighter gradient effect at the bottom of the letterform.

ALPHABET PRACTICE

Use the space below to practice drawing this Harry Potter-inspired alphabet. The first line features grayed-out letterforms to help guide your lettering. Start with a wireframe and gradually build out the thickness of each individual letterform. Try lettering a spell or creature name in this alphabet style.

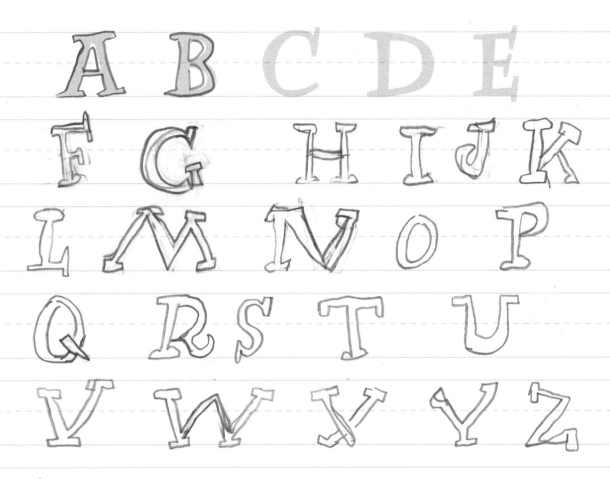

HAND LETTER YOUR NAME

Practice lettering your name in the style of the Muggle Mischief alphabet on the previous page. Follow the steps below from wireframe to full color. Looking to shake things up? Try lettering your name using one of the styles illustrated opposite, such as a dimension drop shadow, outline, or shaky edge.

1

2

3

4

Once you learn how to draw letterforms, you can stylize them in many ways to give them different finished effects. A letter drawn with a dimensional drop shadow can look very different than the exact same letter drawn with a shaky edge or outline. Check out some of the examples below. How many ways can you stylize the Muggle Mischief alphabet from page 16? Give it a try in the space below.

LEFT-FACING DIMENSIONAL
DROP SHADOW WITH INLINE

OUTLINE WITH
SHADOWED OUTLINE

SMALL RIGHT-FACING DROP
SHADOW WITH INNER DETAILS

CHISELED INNER DIMENSION

SHAKY-EDGE LETTERFORM
WITH COLORED-IN COUNTER

RIGHT-FACING DIMENSIONAL DROP
SHADOW WITH INNER GRADIENT

SHAKY-EDGE LETTERFORM
WITH DOTTED INLINE

THICK OUTLINE WITH
INNER GRADIENT

BASILISK FANG ALPHABET

This serif alphabet is inspired by lettering seen throughout the movies. It is defined by its condensed, sharp-serifed styling, and inner lettering detail. Evaluate the letterforms below, and learn how to draw them from wireframe to full color by following the construction guide below.

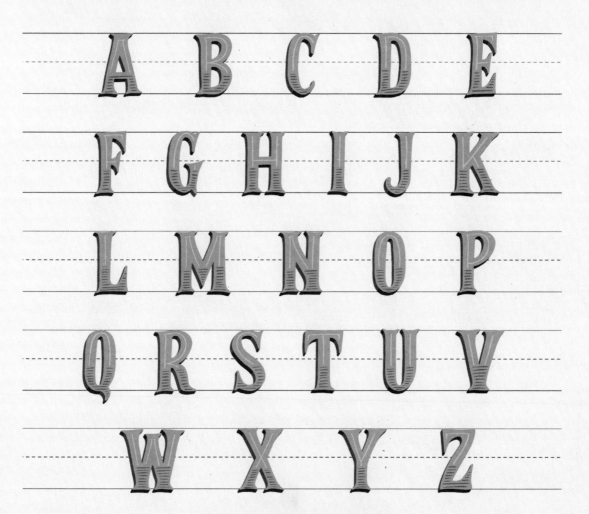

HOW TO DRAW LETTERFORMS

Begin with a basic wireframe. Keep it simple, as it will serve as a guide in future steps.

Visually break the letterform into a series of shapes. Each of the serifs should be gradually curved and sharp in appearance.

Clean up the letterform while adding dimension and inner lettering details. The finished sketch should have clean linework.

Trace over your sketch. Start with the green "R" letterform, and then add a darker drop shadow. Add inner details for a nice effect.

ALPHABET PRACTICE

Use the space below to practice drawing the Basilisk Fang alphabet. The first line features grayed-out letterforms to help guide your lettering. Start with a wireframe, then gradually build out the thickness of each individual letterform. Try lettering a spell or creature name in this style.

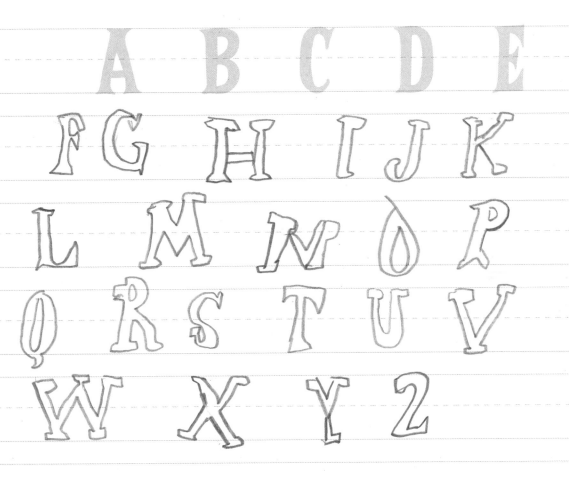

PRIVET DRIVE ALPHABET

This sans serif alphabet is inspired by lettering seen throughout the movies. This alphabet is defined by its chiseled inner dimension and tall, condensed appearance. Evaluate the letterforms below, and draw them from wireframe to full color by following along with the lettering construction guide seen below.

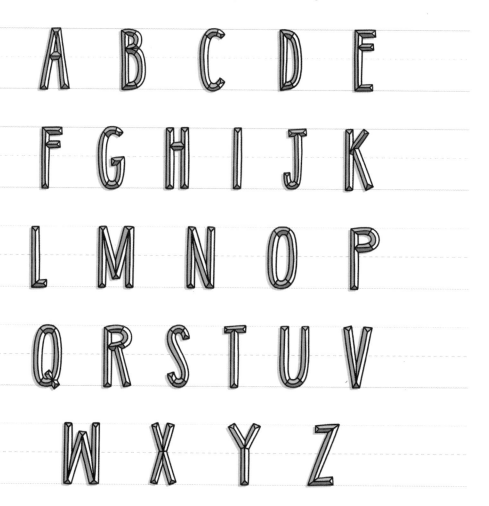

HOW TO DRAW LETTERFORMS

Begin with a basic wireframe. Keep it simple, as it will serve as a guide in future steps.

Visually break the letterform into a series of shapes. The result should be a tall and condensed letterform.

Clean up the letterform and add a chiseled inner dimension. The ends of each stroke should have small triangular shapes.

Trace over your sketch in black ink. Add green, gold, gray, and white coloring to the chiseled inner dimension.

ALPHABET PRACTICE

Use the space below to practice drawing the Privet Drive alphabet. The first line features grayed-out letterforms to help guide your lettering. Start with a wireframe, then gradually build out the thickness of each individual letterform. Try lettering one of the Dursley family's names in this alphabet style.

A B C D E

DRAWING SIMPLE ILLUSTRATIONS

Integrating simple illustrative elements around your hand lettering can make a composition more dynamic. Follow along with the steps below to create some fun icons from the Harry Potter movies. Use the space on the next page to practice drawing each of these icons.

1 WIREFRAME **2** ROUGH SKETCH **3** REFINE SKETCH **4** COLORIZE

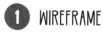 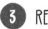

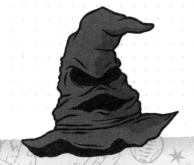

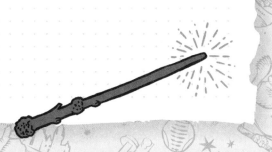

LETTERING & ILLUSTRATION COMPOSITION STEP-BY-STEP

Also known as "Liquid Luck," *Felix Felicis* is a potion that makes whomever drinks it lucky for a set period of time. Meant to be taken sparingly, it can also cause recklessness and overconfidence.

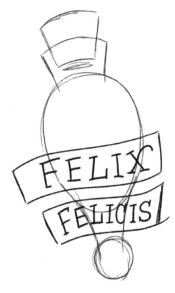

1 WIREFRAME

Start by drawing the loose shape of the potion bottle. Break the container down into a series of shapes. Add two wavy rectangular banner shapes and some wireframe lettering.

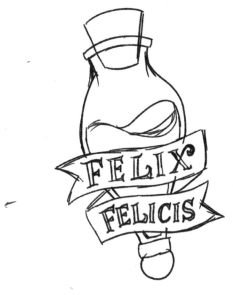

2 ROUGH SKETCH

Adjust the curves and add a rim to the top of the bottle and liquid inside. Build out the thickness of each letterform over your wireframe. Add pointed ends to the banners.

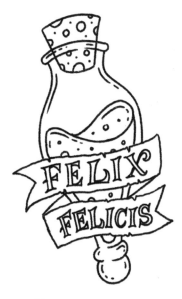

3 REFINE SKETCH

Refine the letterforms by tracing over your rough sketch. Add small circular details to the cork, bubbles in the liquid, and small tear marks on the tops and bottoms of the banners.

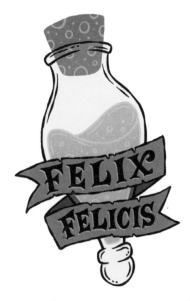

4 COLORIZE

To colorize the artwork, trace over your sketch with dark ink. In the movies *Felix Felicis* appears in yellow and gold tones. Use a similar color scheme in your final artwork.

LETTERING & ILLUSTRATION COMPOSITION STEP-BY-STEP

Quirky and mysterious, Siruis Black was the only surviving member of Harry's family, providing love and support when he needed it.

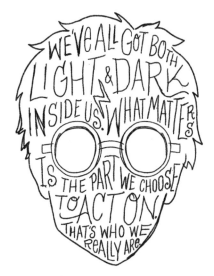

1 **WIREFRAME**

Draw an outline of a boy's head with messy hair. Add a pair of circular glasses in the middle and some wireframe lettering starting from the top and working down. Each letter should fit within the head and around the glasses.

2 **ROUGH SKETCH**

Build out the thickness of each letter over your wireframe. Note how each letterform is a combination of shapes. Add more rough detail to the hair and tape around the bridge of the glasses.

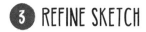

3 **REFINE SKETCH**

Refine each letterform by tracing over your rough sketch. Clean up all of the linework in the lettering and illustrative elements. Add several diagonal highlights to Harry's glasses for a nice finishing touch.

4 **COLORIZE**

To colorize your artwork, trace over your sketch with ink. Use a limited color palette, like gold, black, and white. If you're creating the art digitally, try adding some texture for a fun, vintage-styled effect.

LETTERING & ILLUSTRATION COMPOSITION PRACTICE

Draw the same thing over and over. Through repetition, the process will become easier over time, and eventually you'll be able to combine certain steps to become more efficient.

Section 4

HOGWARTS

INTRODUCTION TO
HOGWARTS

Hogwarts School of Witchcraft & Wizardry is one of the finest schools in the wizarding world. Located in the Scottish Highlands, Hogwarts is home to students, teachers, & ghosts and is made up of four main houses. Each house is named after the last name of the original founder: Godric Gryffindor, Salazar Slytherin, Rowena Ravenclaw, & Helga Hufflepuff. As complex as it is large, the impressive castle is comprised of many rooms, passages, dungeons, & moving staircases that hold centuries of secrets. Many of these mysteries are uncovered by Harry, Ron & Hermione throughout their time at Hogwarts.

In this section you'll learn to hand letter & illustrate your own Hogwarts Express ticket, professor names, crests, & more.

HOGWARTS PROFESSOR NAMES LETTERING

Practice lettering two of the professors' names below. Start with simplified wireframe lettering and gradually build out the thickness of each letterform. Once your lettering is refined, add small details like inlines, or fill in counter spaces. Finalize the lettering by inking and colorizing.

1 SEVERUS SNAPE **2** SEVERUS SNAPE

3 SEVERUS SNAPE **4** SEVERUS SNAPE

1 ALBUS DUMBLEDORE **2** ALBUS DUMBLEDORE

3 ALBUS DUMBLEDORE **4** ALBUS DUMBLEDORE

HOGWARTS CREST COMPOSITION STEP-BY-STEP

A crest is a simplified heraldic symbol that identifies a family, group of individuals, or institution. It is used when a full coat of arms and motto is too detailed a design.

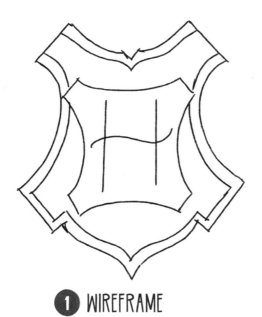

① WIREFRAME

Start by drawing a loose crest shape in the center of your page. Add a border to the crest and a shape in the center of the crest to hold the wireframe letter "H" for Hogwarts.

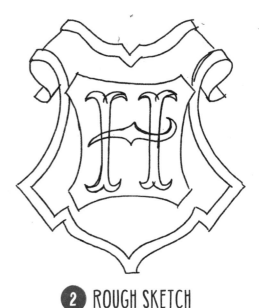

② ROUGH SKETCH

Using your wireframe as a guide, roughly build out the thickness of the "H" letterform while adding sharp serifs to the ends of each stroke along with a curved crossbar. Add curled portions to the crest in the upper left and upper right areas.

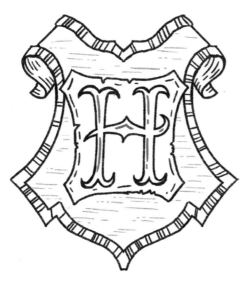

③ REFINE SKETCH

Refine the center letterform by tracing over your rough sketch. Add lines to the crest border, along with weathered horizontal lines within the crest shape. Clean linework will make the final step easier.

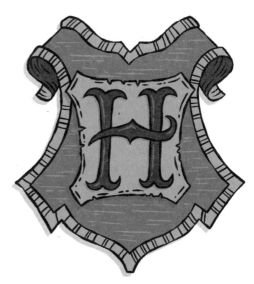

④ COLORIZE

To colorize your artwork, trace over your sketch with ink. A range of golds work well for the crest coloring, with a darker black or gray for accents and the "H" letterform. Try adding a soft gray-colored shadow behind the crest to help ground it.

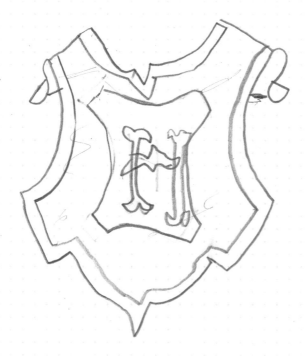

HOGWARTS EXPRESS TICKET
LETTERING COMPOSITION STEP-BY-STEP

The Hogwarts Express ticket is presented to any student who attends Hogwarts School of Witchcraft and Wizardry. The Hogwarts Express train leaves from Kings Cross Station in London and is invisible to Muggles. Follow the steps below to draw your own magical ticket.

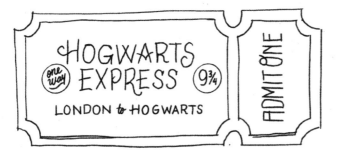

1 WIREFRAME

Start by drawing rectangular shapes with inverted rounded corners. Once you have drawn the shapes, add wireframe lettering within them. Use circular shapes as holding devices for smaller details.

2 ROUGH SKETCH

Roughly start to sketch over your wireframe. Plan out each label's lettering style. Break each character down into a series of shapes, then gradually thicken them. Layer in additional border linework, which will hold the various shapes and details developed in the next step.

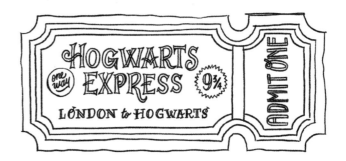

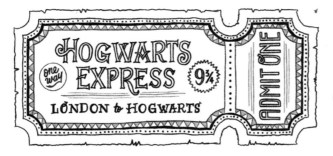

3 REFINE SKETCH

Once the rough sketch composition is in a good place, refine the hand lettering. Spend time adding small shapes and dots inside the border. Clean up the linework to allow for an easier final colorization step.

4 COLORIZE

To colorize your artwork, trace over your sketch with ink. Use a range of parchment-inspired beige tones, gold, and red. Start with lighter colors first and gradually layer in darker colors. For example, color the lighter brown shape of the ticket, followed by the gold border details.

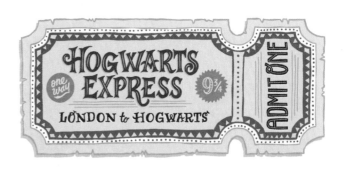

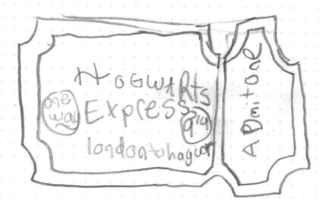

Layering multiple patterns and simple shapes together can create a fun & unique border.

HOGWARTS CLASS POSTER COMPOSITION STEP-BY-STEP

There are many interesting magical skills to be learned in the wizarding world, and most are taught at Hogwarts. Some of these classes include: Transfiguration, Charms, Potions, History of Magic, and Defense Against the Dark Arts. Follow the steps below to hand letter your own poster for some of the classes at Hogwarts. Use the adjacent page to practice these examples or create your own custom posters for your favorite classes.

WIREFRAME	ROUGH SKETCH	REFINE SKETCH	COLORIZE

Start out with a basic wireframe as a guide for your artwork. As you progress, add a border and build up the thickness of the lettering. Add more detail to the cauldron illustration then some dots and sparkles scattered around the poster design. Try using a bright color scheme like pink and yellow for the final colorized sign.

WIREFRAME	ROUGH SKETCH	REFINE SKETCH	COLORIZE

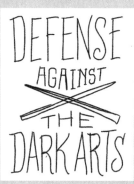 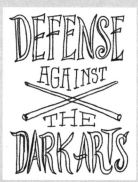 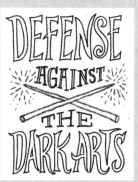 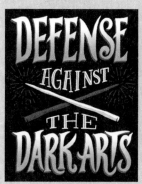

Begin by drawing two crossed wands in the center of the design, along with lettering above and below. As you move forward, build out the thickness of each letterform. Use a sharp and sinister lettering style for the words "defense" and "dark arts" to push the dark theme. Sparkles at the ends of each wand add a nice effect. When it comes time to add color, try using dark tones—black for the background—along with white and green lettering.

 Don't forget to leave gaps around your lettering to accommodate flourishes and decorative linework. Adding these kinds of small details can make for a much more dynamic composition.

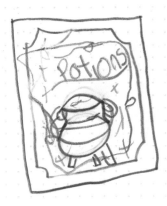

Section 5
GRYFFINDOR HOUSE

INTRODUCTION TO
GRYFFINDOR HOUSE

Gryffindor house was founded by Godric Gryffindor and is one of the four main houses of Hogwarts School of Witchcraft and Wizardry. Gryffindor house has been home to some of the most well-known characters in the Harry Potter series, including Harry Potter, Albus Dumbledore, Ron Weasley, Hermione Granger, and Minerva McGonagall. The Sorting Hat chooses students who embody essential Gryffindor traits, such as chivalry, nerve, daring, bravery & determination.

Gryffindor's crest features its house colors of scarlet and gold. The emblematic animal of Gryffindor is the lion, which embodies its house traits of bravery and courage.

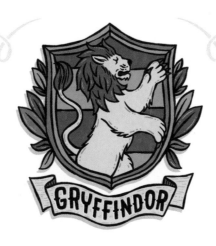

GRYFFINDOR HOUSE ALPHABET

The Gryffindor house-inspired alphabet is a strong dimensional slab serif lettering style. The scarlet and gold letterforms are bold and proud, inspired by the primary Gryffindor house traits of bravery and courage. Evaluate the alphabet below, and learn how to draw it from wireframe to full color.

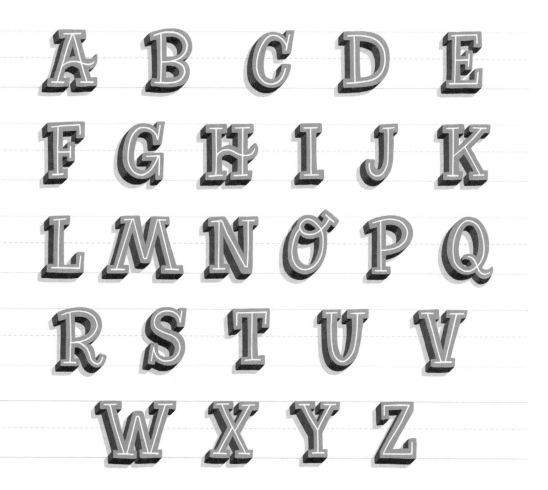

HOW TO DRAW LETTERFORMS

Begin with a basic wireframe. Keep it simple, as it will serve as a guide in future steps.

Visually break the letterform into a series of shapes, starting with the vertical strokes of the letter.

Add thick dimensional lines. Darken the parts of the letter that faces down. Add an inline detail for a finishing touch.

Trace over your sketch. Start with the lightest color: gold. Then build out the darker scarlet dimension.

ALPHABET PRACTICE

Use the space below to practice drawing the Gryffindor house alphabet. The first line features grayed-out letterforms to help guide your lettering. Start with a wireframe and gradually build out the thickness of each letterform. Try lettering your name in the Gryffindor house alphabet style.

A B C D E

GRYFFINDOR HOUSE TRAITS

Practice lettering some of the main Gryffindor house traits below. Start with simplified wireframe lettering and gradually build out the thickness of each letterform. Once your lettering is refined, add small details within and/or around each letterform. Finalize the lettering by inking and colorizing.

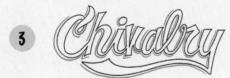
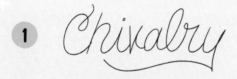

1 DARING

2 DARING

3 DARING

4 DARING

1 BRAVERY

2 BRAVERY

3 BRAVERY

4 BRAVERY

DRAW A GRYFFINDOR HOUSE CREST

House crests have been around for hundreds of years, dating back to medieval times. Each crest features designs that are unique to a specific individual, family, or group. Follow the steps below to draw a Gryffindor house crest featuring the house animal, the lion, on a shield.

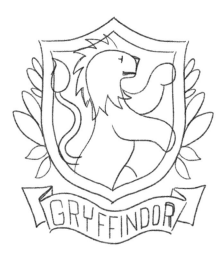

1 WIREFRAME

Start with basic wireframing of the shield, banner, and lion—but stay away from adding any detail at this stage. Instead, focus on creating a solid wireframe foundation to work from.

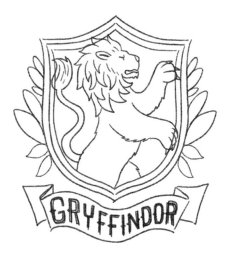

2 ROUGH SKETCH

Roughly start to sketch over your wireframe. Add loose detail to the lion and some additional linework to the shield. Thicken up the Gryffindor lettering contained within the banner.

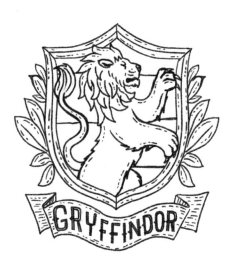

3 REFINE SKETCH

Once the rough sketch composition is in a good place, refine the letterforms, shield, and lion by tracing over the sketch. Add details like leaf veins, hairs, and banner textures to the entire composition.

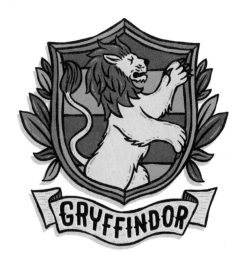

4 COLORIZE

To colorize your artwork, trace over your sketch with ink. Trace over the linework with black ink. When it's time to add color, use a variety of scarlets and golds throughout the composition.

GRYFFINDOR HOUSE CREST PRACTICE

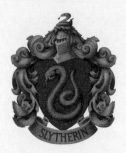

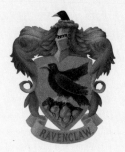

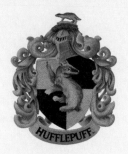

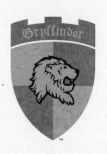

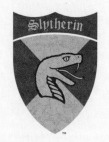

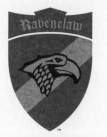

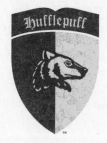

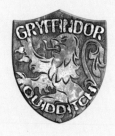

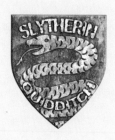

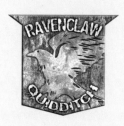

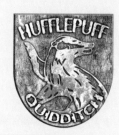

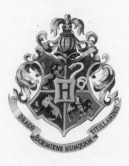

Great ideas can be found anywhere. You may feel inspired by the shape of one crest and the flourishes of another. Combine the different elements to make a unique crest!

DRAW YOUR OWN HOUSE CREST

Use the faint shapes below as guides or thought-starters to create your own personal house crest.
If you're feeling uninspired, look no further than the adjacent page for some great crest inspiration!

Gryffidor

DRAW A CUSTOM ALPHABET

You've drawn the Gryffindor house alphabet on page 42, so now it's time to create your own custom alphabet. It can be sans serif or serif, thick or thin, tall or short, with hard edges or rounded ones. Check out the next page for some great lettering inspiration for your alphabet. Use the guides below to help plan out each letterform and don't forget to give your new alphabet a name!

NAME YOUR ALPHABET: _____

A B C D E F

G H I J K L M

N O P Q R S

T U V W X Y Z

TIP Begin with the letters R, O, S, F, and G, as they typically reveal defining characteristics that can be used throughout the rest of your alphabet. For example, the bowl of the "R" lays the groundwork for drawing a "B," and the arms that make up the letter "F" can inspire the arms of the "E."

Where is the **Chosen One?**

EXPECTO PATRONUM!

MAGICAL CREATURES

THESE ARE **DARK TIMES**

PETRIFICUS TOTALUS!

THE **BATTLE** OF HOGWARTS

DARK MARK SPARKS PANIC

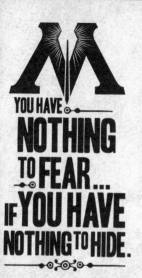

M

YOU HAVE **NOTHING** TO FEAR... IF YOU HAVE NOTHING TO HIDE.

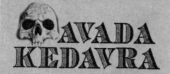

AVADA KEDAVRA

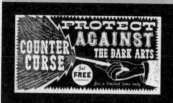

PROTECT AGAINST THE DARK ARTS

COUNTER CURSE

Get FREE

for a limited time only

Blood-Traitor

Incendio

Hogwarts

CRUCIATUS

Harry Potter!

SO LONG IT'S BEEN.

Highly LOGICAL

Expulsio!

PERHAPS our friend's **LOYALTIES** lie ELSEWHERE

YOU-KNOW-WHO STRONGER THAN EVER AS ATROCITIES PERSIST

SNATCHER

EXPELLIARMUS!

The **UNBREAKABLE VOW**

GRYFFINDOR HOUSE CHARACTER LETTERING

Practice lettering Gryffindor character names within the Sorting Hat speech bubbles on the following page. Allow your hand-lettering style to take on some of the personality of the character. Start with simplified wireframe lettering and gradually build out the thickness of each letterform. Once your lettering is refined, add details within and/or around the letterforms. Finish the lettering by inking and coloring. Challenge yourself by also lettering some of the following Gryffindor student names: Neville Longbottom, Ginny Weasley, and Lavender Brown.

1. Harry Potter
2. Harry Potter
3. Harry Potter
4. **Harry Potter**

1. Hermione Granger
2. Hermione Granger
3. Hermione Granger
4. Hermione Granger

1. RON WEASLEY
2. RON WEASLEY
3. RON WEASLEY
4. RON WEASLEY

HARRY POTTER LETTERING COMPOSITION STEP-BY-STEP

Throughout the movies, Harry Potter relies on the Marauder's Map, a magical parchment showing where everyone is located within the Hogwarts castle premises. Practice hand lettering the quote below, which activates the blank map when a wand tip is placed on it.

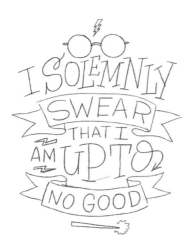

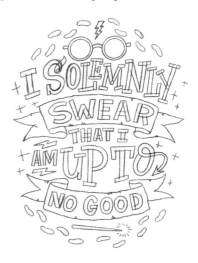

1 WIREFRAME

Start with a basic wireframe. Stack the words on top of one another, fitting each character into the composition like a puzzle piece to create a tight lettering lockup. Accentuate the important words within banners.

2 ROUGH SKETCH

Roughly build out the thickness of each letterform over your wireframe. Add slab serifs to some words while keeping other words sans serif. Surround the composition with small footsteps and sparkles.

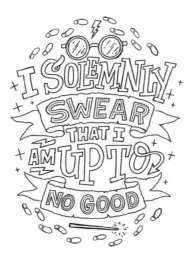

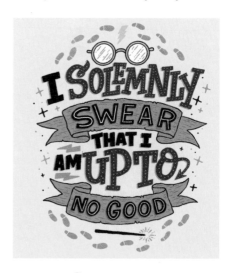

3 REFINE SKETCH

Once the rough sketch composition is in a good place, refine the letterforms by tracing over the sketch. Add inlines to the words within the banners and details to the small illustrations.

4 COLORIZE

To color your artwork, trace over your sketch with ink. Use black ink to trace over the linework. When it's time to add color, use a variety of reds and golds for each letterform.

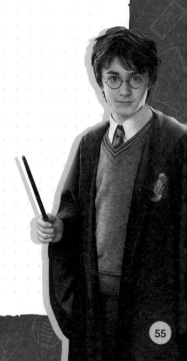

ALBUS DUMBLEDORE LETTERING COMPOSITION STEP-BY-STEP

Ability is nothing if we do not make the right choices. The quote below is spoken by Albus Dumbledore, who provides wisdom throughout the movies. Follow the four steps below to hand letter this quotation.

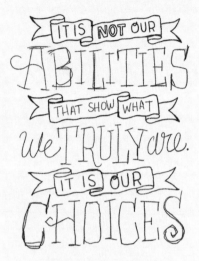

1 WIREFRAME

Start with a basic wireframe. Stack the words on top of one another and use a few different lettering styles like serif, script, and sans serif to create variation and interest.

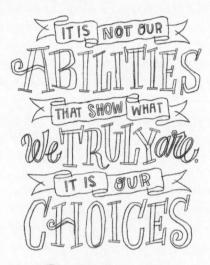

2 ROUGH SKETCH

Roughly build out the thickness of each letterform over your wireframe. Add sharp serifs to the ends of each stroke. Avoid getting overly detailed at this stage.

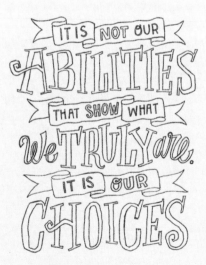

3 REFINE SKETCH

Once the rough sketch composition is in a good place, refine the letterforms by tracing over the sketch. Clean linework will make the final step much easier.

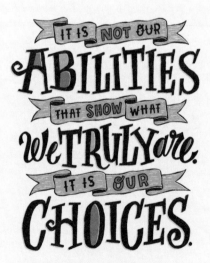

4 COLORIZE

To colorize your artwork, trace over your sketch with ink. Use black ink to trace over the linework and a variety of reds and golds to colorize each letterform. Try filling in the counterspaces in each word for an added touch.

HERMIONE GRANGER LETTERING COMPOSITION STEP-BY-STEP

Hermione Granger has always provided strength and logical insight during times of peril. She overcomes her fear of using Lord Voldemort's name when she recites the phrase below.

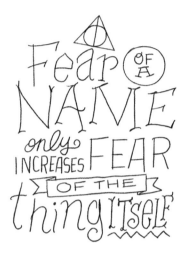

1 WIREFRAME

Start with a basic wireframe. Stack the words on top of one another and add variation by making important words larger than others. Don't be afraid to stack smaller words to save space.

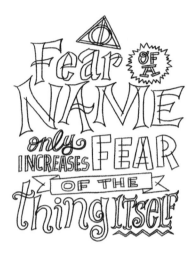

2 ROUGH SKETCH

Build out the thickness of each letter over your wireframe. This is an important step to establish each individual word's lettering style. Note how each letterform is a combination of shapes.

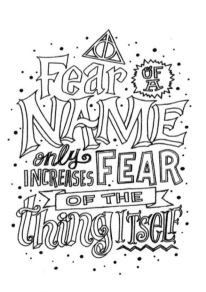

3 REFINE SKETCH

When you're happy with the rough sketch composition, refine the letterforms by tracing over the sketch. Add some dimension to important words and introduce small starry dots to surround the composition.

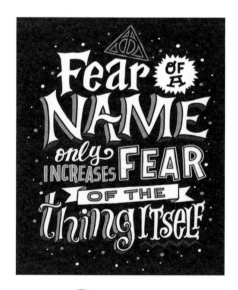

4 COLORIZE

To colorize your artwork, trace over your sketch with ink. Trace over the linework with black ink. When it's time to add color, use a variety of blues to play up the dark and cold theme.

 Try adding dimension **to** certain words within your composition. This can be a great way to really emphasize **the** most important words in your artwork.

ANOTHER ALBUS DUMBLEDORE LETTERING COMPOSITION STEP-BY-STEP

Dumbledore says this to Harry when he finds him looking at his parents in the Mirror of Erised. Follow the steps below to hand letter the quotation.

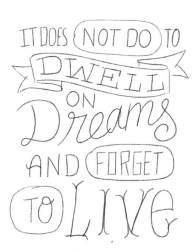

1 WIREFRAME

Start with a basic wireframe. Highlight important words by making them larger, or encase them in banners or shapes. It's okay to allow some of your rough lettering style to come through at this stage.

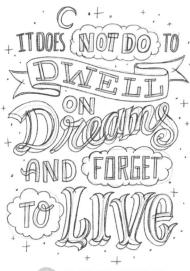

2 ROUGH SKETCH

Build out the thickness of each letterform over your wireframe. Make some words serif and others sans serif or script. Add dimension to words you are looking to emphasize. Lastly, surround the entire composition with stars and a moon.

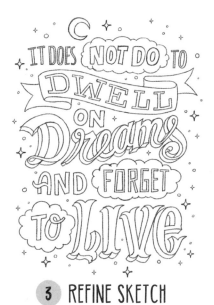

3 REFINE SKETCH

Once the rough sketch composition is working well, refine the letterforms by tracing over the sketch. Clean linework will make the final step much easier.

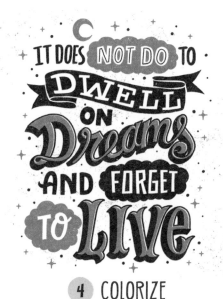

4 COLORIZE

To colorize your artwork, trace over your sketch with ink, using black for the linework. When it's time to add color, try using blues and greens to push the dream concept.

LETTERING COMPOSITION PRACTICE

Section 6

HUFFLEPUFF
HOUSE

INTRODUCTION TO
HUFFLEPUFF HOUSE

Hufflepuff house was founded by Helga Hufflepuff *and* is one of *the* four main houses of Hogwarts School of Witchcraft *and* Wizardry. Hufflepuff house has been home to well-known characters in the Harry Potter series, including Cedric Diggory, Nymphadora Tonks, *and* Pomona Sprout. The Sorting Hat chooses students that embody essential Hufflepuff traits, such as dedication, loyalty, patience *&* humility.

Hufflepuff's crest features its house colors of canary yellow *and* black. The emblematic animal of Hufflepuff is *the* badger, which embodies its house traits of loyalty *and* tenacity.

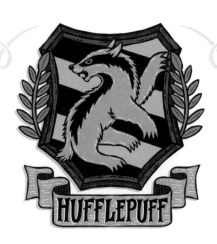

HUFFLEPUFF HOUSE ALPHABET

The Hufflepuff house-inspired alphabet is a strong dimensional slab serif lettering style. The yellow and black letterforms are inspired by primary Hufflepuff house traits of tenacity, loyalty, and hard work. Assess the alphabet below, and learn how to draw it from wireframe to full color.

HOW TO DRAW LETTERFORMS

Begin with a basic wireframe. Keep it simple, as it will serve as a guide in future steps.

Visually break the letterform into a series of shapes, starting with the vertical strokes of the letter. Add barbs and serifs last.

Clean up the letterform, and add an inline and outline details for a nice clean finishing touch.

Trace over your sketch in black ink. Use yellow for the inline and outline letterform details.

ALPHABET PRACTICE

Use the space below to practice drawing the Hufflepuff house alphabet. The first line features grayed-out letterforms to help guide your lettering. Start with a wireframe and gradually build out the thickness of each letterform. Start with lettering your name in Hufflepuff house alphabet style.

A B C D E

HUFFLEPUFF HOUSE TRAITS

Practice lettering primary Hufflepuff house traits below. Start with simplified wireframe lettering and gradually build out the thickness of each letterform. Once your lettering is refined, add small details within and/or around each letterform. Finish the lettering by inking and coloring.

1 DEDICATION **2** DEDICATION

3 DEDICATION **4** DEDICATION

1 Loyalty **2** Loyalty

3 Loyalty **4** Loyalty

To avoid the lettering becoming too busy, limit yourself to two to three colors for each composition. Also, choose a range of colors that complement one another.

1. PATIENCE 2. PATIENCE

3. PATIENCE 4. PATIENCE

1. HUMILITY 2. HUMILITY

3. HUMILITY 4. HUMILITY

HOW TO DRAW A HUFFLEPUFF HOUSE CREST

House crests have been around for hundreds of years, dating back to medieval times. Each crest features designs that are unique to a specific individual, family, or group. Following the steps below, draw a Hufflepuff house crest featuring the badger—the house animal—on a shield.

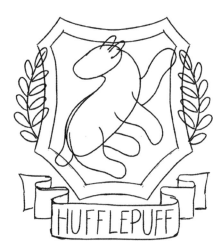

1 WIREFRAME

Start with basic wireframing of a shield, banner, and badger. Avoid adding any detail at this stage, instead focus on creating a solid wireframe foundation to work from.

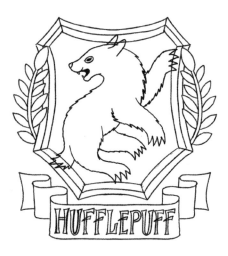

2 ROUGH SKETCH

Roughly start to sketch over your wireframe. Add loose detail to the badger and some additional linework to the shield. Thicken up the Hufflepuff lettering contained within the banner.

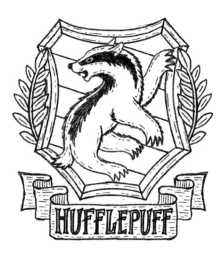

3 REFINE SKETCH

Once the rough sketch composition is in a good place, refine the letterforms, shield, and badger by tracing over the sketch. Add details like leaf veins, fur, and banner textures to the entire composition.

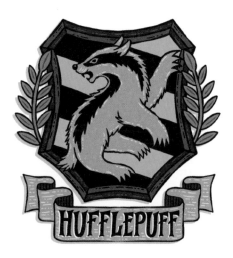

4 COLORIZE

To colorize your artwork, trace over your sketch with ink. Use black ink for the linework. When it's time to add color, use a variety of yellows, grays, and black throughout the composition.

DRAW A CUSTOM ALPHABET

You've drawn the Hufflepuff house alphabet on page 64. Now it's time to create your own custom alphabet. It can be sans serif or serif, thick or thin, tall or short, with rounded or hard edges. Take a look at the adjacent page for some great lettering inspiration for your alphabet. Use the guides below to help plan out each letterform and don't forget to give your new alphabet a name!

NAME YOUR ALPHABET: _____

 Begin with the letters R, O, S, F, and G, as they typically reveal defining characteristics that can be used throughout the rest of the alphabet. For example, the bowl of the "R" lays the groundwork for drawing a "B" and the arms that make up the "F" can inspire the arms of the "E."

THE BATTLE OF HOGWARTS

THE DARK MARK

EXPECTO PATRONUM!

PETRIFICUS TOTALUS!

GOOD vs. EVIL

PERHAPS our friend's LOYALTIES lie ELSEWHERE

MORSMORDRE

Incendio

YOU HAVE NOTHING TO FEAR... IF YOU HAVE NOTHING TO HIDE.

PROTECT AGAINST THE DARK ARTS

COUNTER CURSE

Set FREE

for a limited time only

Voldemort™

DARK MARK SPARKS PANIC

WICKED SCAR!

THE DARK MARK

MAGICAL CREATURES

ENGORGIO!

DARK MARK SPARKS PANIC

Expulsio!

OBLIVIATE

Beauxbatons

HE WHO MUST NOT BE NAMED

DO NOT ENTER!
Without the Express Permission of Regulus Arcturus Black

CONFRINGO!

HUFFLEPUFF HOUSE CHARACTER LETTERING

Practice lettering Hufflepuff character names within the Sorting Hat speech bubbles on the adjacent page. Allow your hand-lettering style to take on some of the personality of the character. Start with simplified wireframe lettering and gradually build out the thickness of each letterform. Once your lettering is refined, add details within and/or around the letterforms. Finish the lettering by inking and colorizing.

1 POMONA SPROUT

2 POMONA SPROUT

3 POMONA SPROUT

4 POMONA SPROUT

1 NYMPHADORA TONKS

2 NYMPHADORA TONKS

3 NYMPHADORA TONKS

4 NYMPHADORA TONKS

1 CEDRIC DIGGORY

2 CEDRIC DIGGORY

3 CEDRIC DIGGORY

4 CEDRIC DIGGORY

CEDRIC DIGGORY LETTERING COMPOSITION STEP-BY-STEP

Cedric Diggory is one of the more popular Hufflepuff students during Harry's time at Hogwarts. Harry competed against Cedric in the Triwizard Tournament, where Cedric urged Harry to take the Goblet of Fire.

1 WIREFRAME

Start with a basic wireframe. Add lettering around a goblet illustration. Work each word into the composition like a puzzle piece to create a tight lettering lockup.

2 ROUGH SKETCH

Roughly build out the thickness of each letterform over your wireframe. Add different styles to each word to create separation. Add more detail to the Goblet of Fire illustration.

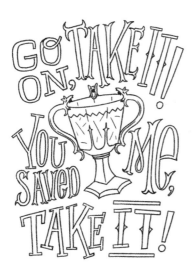

3 REFINE SKETCH

Once the rough sketch composition is looking good, refine the letterforms by tracing over the sketch. Try to keep the entire composition locked up tightly.

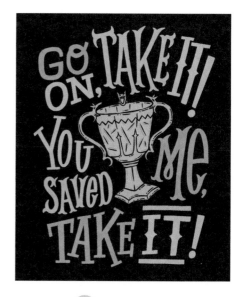

4 COLORIZE

To colorize your artwork, trace over your sketch with ink. Trace over the linework with a variety of grays and blues. Using a dark background like black will make the composition pop.

NYMPHADORA TONKS LETTERING COMPOSITION STEP-BY-STEP

Tonks is an Auror and a member of the Order of the Phoenix. She is funny, feisty, and clumsy—just don't call her Nymphadora! Follow each step below to bring this classic Tonks quote to life.

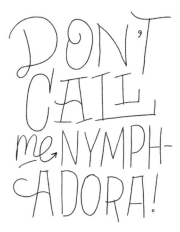

1 WIREFRAME

Start with a basic wireframe. Stack the words on top of one another, and add variation by making important words larger than others. Shake things up by hyphenating "Nymphadora" to split over two lines.

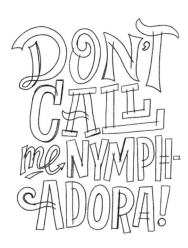

2 ROUGH SKETCH

Build out the thickness of each letter over your wireframe. This is an important step to establish individual word lettering styles. Note how each letterform is a combination of shapes.

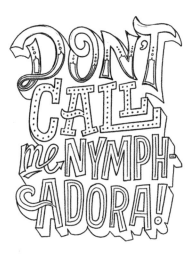

3 REFINE SKETCH

When the rough sketch composition is in a good place, refine the letterforms by tracing over the sketch. Add a dimension to the entire composition, along with inner lettering details.

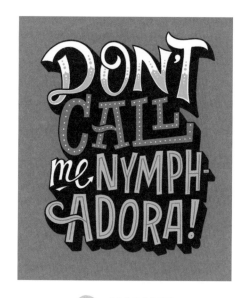

4 COLORIZE

To colorize your artwork, trace over the sketch with ink. Use dark blue ink to trace over the linework. When it's time to colorize, use a variety of bright colors like red, turquoise, and gold.

LETTERING COMPOSITION PRACTICE

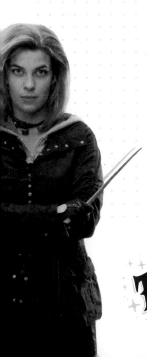

TIP Try adding different lettering details ✪ certain words. Dots, flourishes, *and* inlines are all fun ways ✪ add interest to your lettering composition.

POMONA SPROUT LETTERING COMPOSITION STEP-BY-STEP

Remember to wear your earmuffs when pulling out a mandrake, otherwise its screams can knock you out—or even kill you if it's a mature plant.

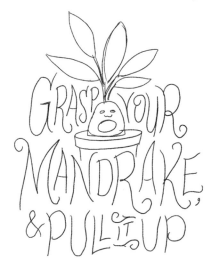

1 WIREFRAME

Start with a basic wireframe of lettering that works around a mandrake plant. Highlight important words by making them larger. Let some of the curvy lettering style come through.

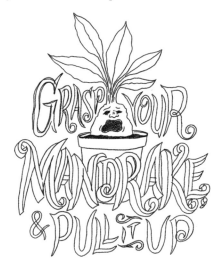

2 ROUGH SKETCH

Build out the thickness of each letterform over your wireframe. Add dimension to the word "mandrake." Add additional detail to the potted mandrake illustration.

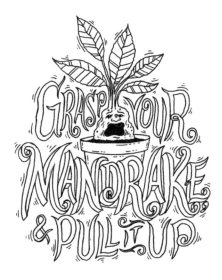

3 REFINE SKETCH

Once you're happy with your rough sketch composition, refine the letterforms by tracing over the lines. Clean linework will make the final step much easier.

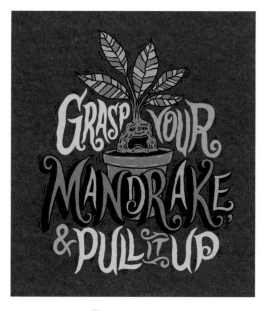

4 COLORIZE

To colorize your artwork, trace over your sketch using black ink over the linework. When it's time to add color, try using earthy tones like brown, green, and tan.

Section 7

Ravenclaw HOUSE

INTRODUCTION TO
RAVENCLAW HOUSE

Ravenclaw house was founded by Rowena Ravenclaw *and* is one of *the* four main houses of Hogwarts School of Witchcraft *&* Wizardry. Ravenclaw house has been home to well-known characters in the Harry Potter series, including Luna Lovegood, Cho Chang, *and* Padma Patil. The Sorting Hat chooses students that embody essential Ravenclaw traits, such as individuality, creativity *&* wit.

Ravenclaw's crest features its house colors of blue *and* silver. In the movies, the emblematic animal of Ravenclaw is *the* raven, which embodies its house traits of intelligence, cleverness, *and* wisdom.

RAVENCLAW HOUSE ALPHABET

The Ravenclaw house-inspired alphabet is a strong dimensional slab serif lettering style. The blue script letterforms are inspired by primary Ravenclaw house traits of creativity, cleverness, and intelligence. Evaluate the alphabet below, and learn how to draw it from wireframe to full color.

Aa Bb Cc Dd Ee
Ff Gg Hh Ii Jj Kk
Ll Mm Nn Oo Pp
Qq Rr Ss Tt Uu
Vv Ww Xx Yy Zz

HOW TO DRAW LETTERFORMS

Begin with a basic wireframe. Keep it simple, as it will serve as a guide in future steps.

Visually break the letterform into a series of shapes, starting with the vertical strokes of the letter.

Clean up the linework on the letterform. Add inner detailing to the bottom of the letterform.

Trace over your sketch. Always start with the lightest color: blue. Then build out the dark outer linework.

ALPHABET PRACTICE

Use the space below to practice drawing the Ravenclaw house alphabet. The first line features grayed-out letterforms to help guide your lettering. Start with a wireframe and gradually build out the thickness of each letterform. Try lettering your name in the Ravenclaw house alphabet style.

Aa Bb Cc Dd Ee

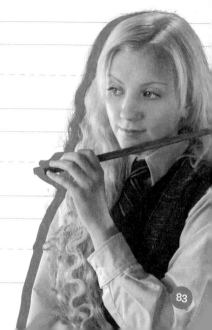

RAVENCLAW HOUSE TRAITS

Practice lettering primary Ravenclaw house traits below. Start with simplified wireframe lettering and gradually build out the thickness of each letterform. Once your lettering is refined, add small details within and/or around each letterform. Finalize the lettering by inking and colorizing.

1 2

3 4

1 2

3 4

TIP Don't be afraid to improvise and add your own styles and details into the practice spaces below. Have fun with each lettering composition!

1

2

3

4

1

2

3

4

HOW TO DRAW A RAVENCLAW HOUSE CREST

House crests have been around for hundreds of years, dating back to medieval times. Each crest features designs that are unique to a specific individual, family, or group. Follow along with the steps below to draw a Ravenclaw house crest featuring the raven—the house animal—on a shield.

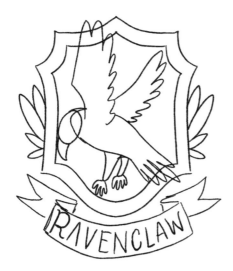

1 WIREFRAME

Start with basic wireframing of a shield, banner, and raven. Stay away from adding any detail at this stage. Focus on creating a solid wireframe foundation to work from moving forward.

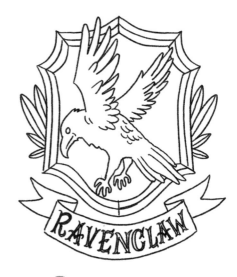

2 ROUGH SKETCH

Roughly start to sketch over your wireframe. Add loose detail to the raven and some additional linework to the shield. Thicken up the Ravenclaw lettering contained within the banner.

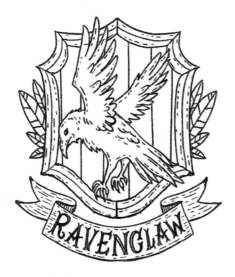
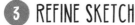

3 REFINE SKETCH

Once the rough sketch composition is in a good place and you are happy with it, refine the letterforms, shield, and raven by tracing over the sketch. Add details like leaf veins, feathers, and banner textures to the entire composition.

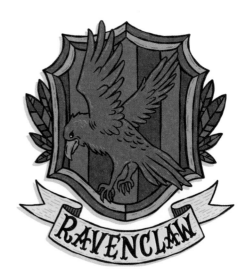

4 COLORIZE

To colorize your artwork, trace over the sketch with ink. Use black ink to trace over the linework. When it's time to add color, use a variety of blues, browns, and grays throughout the composition.

DRAW A CUSTOM ALPHABET

You've drawn the Ravenclaw house alphabet on page 82. Now it's time to create your own custom alphabet. It can be sans serif or serif, thick or thin, tall or short, with rounded or hard edges. Take a look at the adjacent page for some great lettering inspiration for your alphabet. Use the guides below to help plan out each letterform and don't forget to give your new alphabet a name!

NAME YOUR ALPHABET: _____

A	B	C	D	E	F

G	H	I	J	K	L	M

N	O	P	Q	R	S

T	U	V	W	X	Y	Z

Begin with the **letters R, O, S, F, and G, as they typically reveal defining characteristics that can be used throughout** the **rest of the alphabet. For example,** the **bowl of the "R" lays the groundwork for drawing a "B"** and **the arms that make up the "F" can inspire** the **arms of the "E."**

PERHAPS our friend's LOYALTIES lie ELSEWHERE

EXPECTO PATRONUM!

MUDBLOOD
The Death Eaters will soon be coming for you!

THESE ARE DARK TIMES

PETRIFICUS TOTALUS!

THE BATTLE OF HOGWARTS

MORSMORDRE

Incendio

M
YOU HAVE NOTHING TO FEAR... IF YOU HAVE NOTHING TO HIDE.

PROTECT AGAINST THE DARK ARTS
COUNTER CURSE
Get FREE
for a limited time only

Voldemort

DARK MARK SPARKS PANIC

Hogwarts

Beauxbatons

MAGICAL CREATURES

GOOD vs. EVIL

MUDBLOOD
The Death Eaters will soon be coming for you!

Expulsio!

OBLIVIATE

Blood-Traitor

STUPEFY!

EXPELLIARMUS!

Incendio

89

RAVENCLAW HOUSE CHARACTER LETTERING

Practice lettering Ravenclaw character names within the Sorting Hat speech bubbles on the adjacent page. Allow your hand-lettering style to take on some of the personality of the character. Start with simplified wireframe lettering and gradually build out the thickness of each letterform. Once your lettering is refined, add details within and/or around the letterforms. Finish the lettering by inking and colorizing.

1. Luna Lovegood
2. Luna Lovegood
3. Luna Lovegood
4. Luna Lovegood

1. Cho Chang
2. Cho Chang
3. Cho Chang
4. Cho Chang

1. PADMA PATIL
2. PADMA PATIL
3. PADMA PATIL
4. PADMA PATIL

LUNA LOVEGOOD LETTERING COMPOSITION STEP-BY-STEP

Many students at Hogwarts think Luna Lovegood is a strange girl, which has led to some giving her the nickname "Loony Lovegood." Luna embodies the true essence of a Ravenclaw and offers many interesting insights throughout the Harry Potter movies, like the quirky quote below.

1 WIREFRAME

Start with a basic wireframe. Stack the words on top of one another, fitting each character into the composition above and below a rough sketch of Luna Lovegood's glasses.

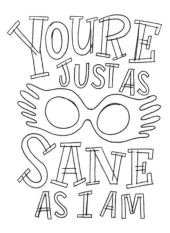

2 ROUGH SKETCH

Roughly build out the thickness of each letterform over your wireframe. Add slab serifs to some words while keeping other words sans serif. Add more detail to the glasses' illustration.

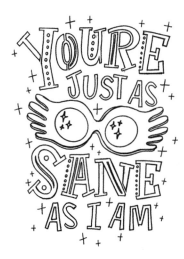

3 REFINE SKETCH

Once the rough sketch composition is in a good place, refine the letterforms by tracing over the sketch. Draw inner and outer lettering details around emphasized words. Adding sparkly stars around the entire composition will pull it all together.

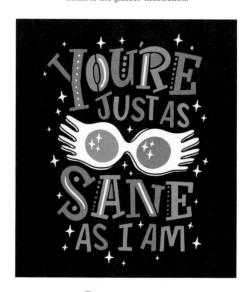

4 COLORIZE

To colorize your artwork, trace over the sketch with ink. Trace over the linework with pink, blue, and white. A black background will help create a nice sense of contrast.

LETTERING COMPOSITION PRACTICE

HELENA RAVENCLAW LETTERING
COMPOSITION STEP-BY-STEP

With this tricky quote, Rowena Ravenclaw's daughter, Helena, helps Harry find the Room of Requirement when he needs somewhere secret for Dumbledore's Army to practice.

 1 WIREFRAME

Start with a basic wireframe. Stack the words on top of one another, and add variation by making important words larger than others. Don't be afraid to stack smaller words to save space.

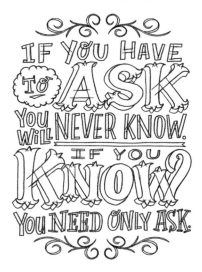

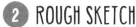 **2 ROUGH SKETCH**

Build out the thickness of each letter over your wireframe. This is an important step to establish each individual words lettering style. Note how each letterform is a combination of shapes.

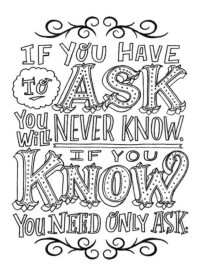

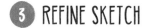 **3 REFINE SKETCH**

When the rough sketch composition is in a good place, refine the letterforms by tracing over the sketch. Add dotted inlines to important words like "ask" and "know."

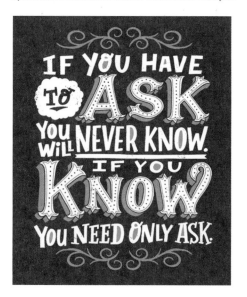

4 COLORIZE

To colorize your artwork, trace over your sketch linework with ink. When it's time to add color, use a variety of white, green, and purple.

LETTERING COMPOSITION PRACTICE

 Try adding dimension to certain words within your composition. This can be an effective way to emphasize the most important words.

ANOTHER LUNA LOVEGOOD LETTERING COMPOSITION STEP-BY-STEP

Despite being teased by other students at Hogwarts for her eccentric behavior, Luna Lovegood always manages to keep a positive mindset.

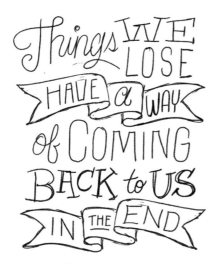

1 WIREFRAME

Start with a basic wireframe. Highlight important words by making them larger, or encase them in banners or shapes. It's okay to allow some of the initial rough lettering style to come through.

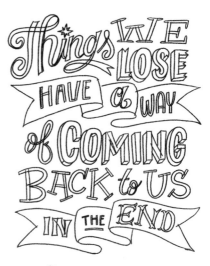

2 ROUGH SKETCH

Build out the thickness of each letterform over your wireframe. Make some words serif and others sans serif or script. Add dimension to words you are looking to emphasize.

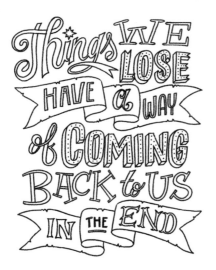

3 REFINE SKETCH

Once the rough sketch composition is in a good place, refine the letterforms by tracing over the sketch. Add dotted inlines and any final details during this step.

4 COLORIZE

To colorize your artwork, trace over your sketch with ink. Use black ink to trace over the linework. When it's time to add color, try using a mixture of magenta and mint green for a fun color scheme.

Section 8

SLYTHERIN HOUSE

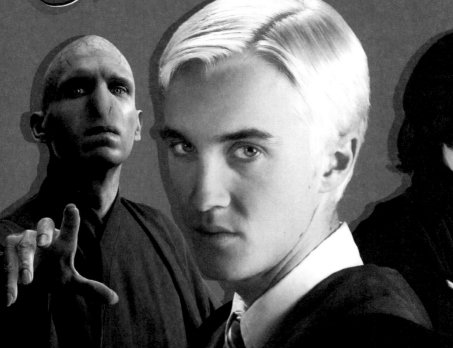

INTRODUCTION TO
SLYTHERIN HOUSE

Slytherin house was founded by Salazar Slytherin and is one of the four main houses of Hogwarts School of Witchcraft and Wizardry. Along with Gryffindor, Slytherin house has been home to some of the most well-known characters in the Harry Potter series, including Draco Malfoy, Severus Snape, Bellatrix Lestrange, and Lord Voldemort. The Sorting Hat chooses students that embody essential Slytherin traits, such as cunning, determination, pride & leadership.

Slytherin's crest features its house colors of emerald green and silver. The emblematic animal of Slytherin is the snake, which embodies its house traits of resourcefulness and ambition.

SLYTHERIN HOUSE ALPHABET

The Slytherin house-inspired alphabet is comprised of sharp serifs and gothic accents. The emerald green and silver letterforms are inspired by primary Slytherin house traits like cunning and determination. Assess the alphabet below, and learn how to draw it from wireframe to full color.

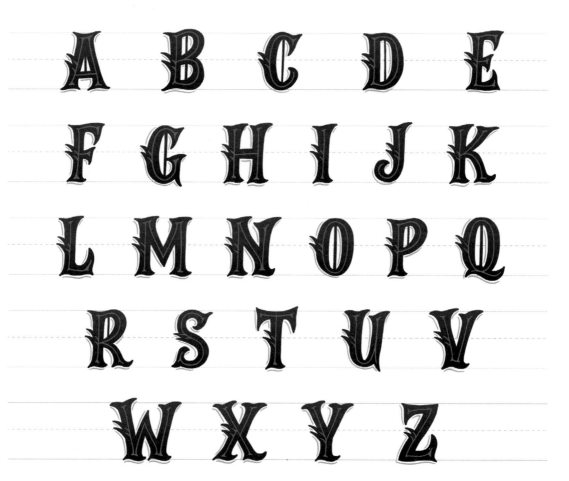

HOW TO DRAW LETTERFORMS

 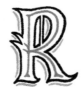

Begin with a basic wireframe. Keep it simple, as it will serve as a guide in future steps.

Visually break the letterform into a series of shapes. The serifs should be nice and sharp. Add two gothic barbs to the stem.

Clean up the letterform while adding an inline with barbs and an outline. The finished effect should have clean linework.

Trace over your sketch. Start with the basic "R" letterform, and add light green inlines and gray outlines at the end.

Use the space below to practice drawing the Slytherin house alphabet. The first line features grayed-out letterforms to help guide your lettering. Start with a wireframe and gradually build out the thickness of each individual letterform. Try lettering your name in the Slytherin house alphabet style.

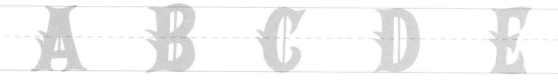

SLYTHERIN HOUSE TRAITS

Practice lettering primary Slytherin house traits below. Start with simplified wireframe lettering and gradually build out the thickness of each letterform. Once your lettering is refined, add small details within and/or around each letterform. Finish the lettering by inking and coloring.

① Ambition ② Ambition

③ Ambition ④ Ambition

HOW TO DRAW A SLYTHERIN HOUSE CREST

House crests have been around for hundreds of years, dating back to medieval times. Each crest features designs that are unique to a specific individual, family, or group. Follow the steps below to draw a Slytherin house crest featuring a snake—the house animal—on a shield.

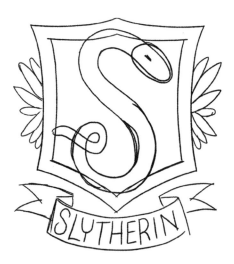

1 WIREFRAME

Start with basic wireframing of a shield, banner, and snake. Stay away from adding any detail at this stage. Instead, focus on creating a solid wireframe foundation to work from moving forward.

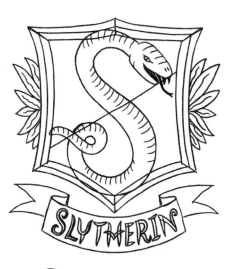

2 ROUGH SKETCH

Roughly start to sketch over your wireframe. Add loose detail to the snake and some additional linework to the shield. Thicken up the snake-like Slytherin lettering contained within the banner.

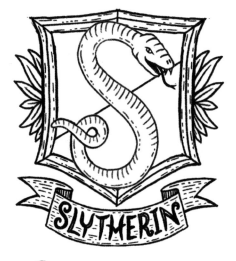

3 REFINE SKETCH

Once you are happy with your rough sketch, refine the letterforms, shield, and snake by tracing over the sketch. Add details like curvy leaf veins, snake scales, and banner textures to the entire composition.

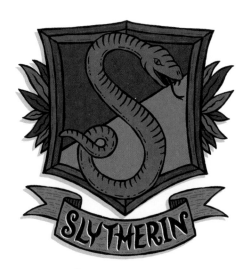

4 COLORIZE

To colorize your artwork, trace over your sketch with ink. Use black ink to trace over the linework. When it's time to add color, use a variety of greens, light grays, and dark grays throughout the composition. A red snake eye makes for a sinister finishing touch.

DRAW A CUSTOM ALPHABET

You've drawn the Slytherin house alphabet on page 100, so now it's time to create your own custom alphabet. It can be sans serif or serif, thick or thin, tall or short, with rounded or hard edges. Take a look at the adjacent page for some great lettering inspiration for your alphabet. Use the guides below to help plan out each letterform and don't forget to give your new alphabet a name!

NAME YOUR ALPHABET: _____

A B C D E F

G H I J K L M

N O P Q R S

T U V W X Y Z

Begin with the letters R, O, S, F, and G, as they typically reveal defining characteristics that can be used throughout the rest of the alphabet. For example, the bowl of the "R" lays the groundwork for drawing a "B" and the arms that make up the "F" can inspire the arms of the "E."

GOOD vs. EVIL

EXPECTO PATRONUM!

PETRIFICUS TOTALUS!

THESE ARE DARK TIMES

THE BATTLE OF HOGWARTS

AVADA KEDAVRA

DARK LORD... MORE SIGHTINGS

YOU HAVE NOTHING TO FEAR... IF YOU HAVE NOTHING TO HIDE.

The UNBREAKABLE VOW

OBLIVIATE

Expulsio!

I WON'T BE SO Forgiving NEXT TIME...

500 GALLEONS ON ANY INFORMATION REGARDING DEATH EATERS ☞ SEE INSIDE FOR FULL DETAILS PG. 3

PROTECT AGAINST THE DARK ARTS
COUNTER CURSE
Get FREE
for a limited time only

MAGICAL CREATURES

HE WHO MUST NOT BE NAMED

THE DARK MARK

DARK MARK SPARKS PANIC

Voldemort™

SNATCHER

Blood-Traitor

Incendio

107

SLYTHERIN HOUSE CHARACTER LETTERING

Practice lettering Slytherin character names within the Sorting Hat speech bubbles on the next page. Allow your hand-lettering style to take on some of the personality of the character. Start with simplified wireframe lettering and gradually build out the thickness of each letterform. Once your lettering is refined, add details within and/or around the letterforms. Finalize the lettering by inking and colorizing. Try lettering some of the Slytherin student names below, or any other famous Slytherins such as Lord Voldemort or Bellatrix Lestrange.

1. DRACO MALFOY
2. DRACO MALFOY
3. DRACO MALFOY
4. DRACO MALFOY

1. PANSY PARKINSON
2. PANSY PARKINSON
3. PANSY PARKINSON
4. PANSY PARKINSON

1. BLAISE ZABINI
2. BLAISE ZABINI
3. BLAISE ZABINI
4. BLAISE ZABINI

DRACO MALFOY LETTERING COMPOSITION STEP-BY-STEP

Throughout the movies, Harry Potter has always despised his nemesis: Draco Malfoy.
Malfoy has always gotten under Harry's skin with comments like the one below.
Practice hand lettering this quote while taking your time to plan and sketch each step.

1 WIREFRAME

Start with a basic wireframe. Stack the words on top of
one another and draw a hand holding a wand at the top.
Emphasize important words by making them larger. Lightly
sketch a swoosh of magic behind the lettering.

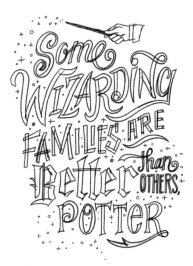

2 ROUGH SKETCH

Roughly build out the thickness of each letterform over
your wireframe. Use a variety of lettering styles from
cursive script to blackletter and serif. Add dots and
sparkles coming from the tip of the wand.

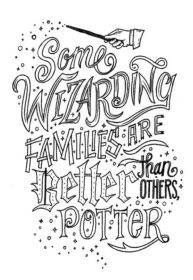

3 REFINE SKETCH

Once the rough sketch composition is looking good, refine
the letterforms by tracing over the sketch. Add inlines and
dots to larger words to add interest and emphasis. Add
final details to the hand, wand, and magical swoosh.

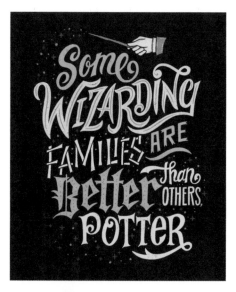

4 COLORIZE

To colorize your artwork, trace over your sketch with ink.
When it's time to add color, use a variety of light greens, blues,
and creams to colorize each letterform. Use muted tones for
the magic sparkles to avoid making the composition too busy.

LETTERING COMPOSITION PRACTICE

SEVERUS SNAPE LETTERING COMPOSITION STEP-BY-STEP

Professor Snape has always provided a brutal dose of honesty to students at Hogwarts. Although he can appear cold at times, there is insight in his words. Follow the four steps below to hand letter this Severus Snape quote.

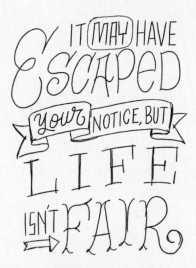

❶ WIREFRAME

Start with a basic wireframe. Stack the words on top of one another, and use a few different lettering styles like serif, script, and sans serif to create variation and interest. Use shapes like arrows and banners to create variation.

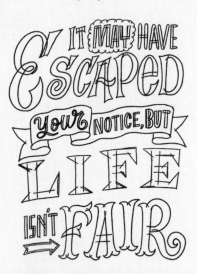

❷ ROUGH SKETCH

Roughly build out the thickness of each letterform over your wireframe. Add sharp serifs to the ends of each stroke. Avoid getting overly detailed in this step.

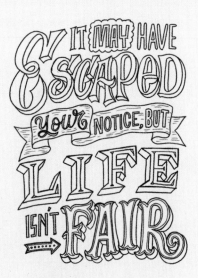

❸ REFINE SKETCH

Once the rough sketch composition is in a good place, refine the letterforms by tracing over the sketch. Add dimensional shadows and inner details to some of the larger words like "escaped," "life," and "fair." Clean linework will make the final step much easier.

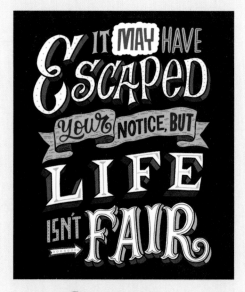

❹ COLORIZE

To colorize your artwork, trace over your sketch with ink. Use black ink to trace over the linework. Then work with a variety of white, red, and gold to color each letterform. A dark background allows the composition to stand out.

 It's completely fine if your art doesn't look identical to *the* art on the adjacent page. Each person draws with their own style. That's what makes art so unique & personal!

VOLDEMORT LETTERING COMPOSITION STEP-BY-STEP

Creepy and evil, the infamous Dark Lord Voldemort commands the Death Eaters and wants to impose his rule of terror on the wizarding world.

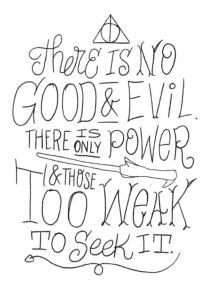

1 WIREFRAME

Start with a basic wireframe. Stack the words on top of one another and add variation by making important words larger than others. Add small illustrations like a wand, snake, and the Voldemort symbol to create visual appeal.

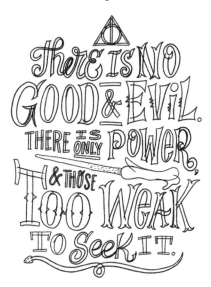

2 ROUGH SKETCH

Build out the thickness of each letter over your wireframe. This is an important step to establish each individual word lettering style. Note how each letterform is a combination of shapes.

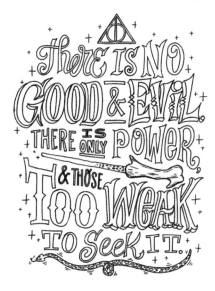

3 REFINE SKETCH

When the rough sketch composition is in a good place, refine the letterforms by tracing over the sketch. Add dimension to the words "good," "evil," and "weak." Surround the entire composition with small stars to pull it all together.

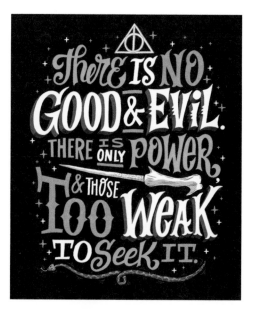

4 COLORIZE

To colorize your artwork, trace over your sketch with ink. Use black ink to trace over the linework. When adding color, try using gold and green. Vary up the location of each color to avoid having too much green or gold in one area.

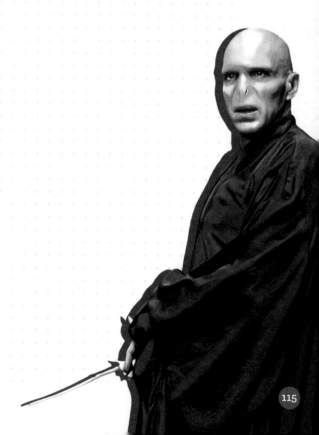

SEVERUS SNAPE LETTERING COMPOSITION STEP-BY-STEP

Hermione's just too brainy for Severus Snape and the only way he can get back at Gryffindor is to dock her house points for answering out of turn.

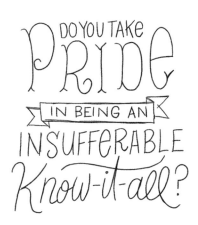

1 WIREFRAME

Start with a basic wireframe. Highlight important words by making them larger, and encase smaller words in a banner shape. It's okay to allow some of the rough lettering style to come through, such as basic cursive script or serifs.

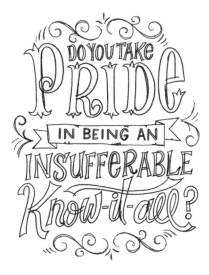

2 ROUGH SKETCH

Build out the thickness of each letterform over your wireframe. Make some words serif, and others sans serif, or cursive script. Add embellishments at the top, bottom, and sides of the composition to pull everything together.

3 REFINE SKETCH

Once you're happy with the rough sketch composition, refine the letterforms by tracing over the sketch. Add dimension to the words "Pride" and "Know-it-all." Clean up your linework to make the final step easier.

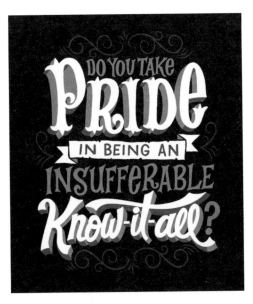

4 COLORIZE

To colorize your artwork, trace over your sketch with ink using black to trace over the linework. When it's time to add color, try using a mixture of white, green, and gray to riff off the Slytherin house color scheme.

LETTERING COMPOSITION PRACTICE

117

Section 9
SPELLS & POTIONS

INTRODUCTION TO
SPELLS and POTIONS

Need to unlock a door, disable an enemy, fix something that is broken, or light up a room? In the wizarding world, there is a spell or potion to fulfill every need—from menial daily tasks to extraordinary summons. The main distinction between the two are that spells can only be used by trained wizards and witches, whereas potions can be used by non-magical folk. To hone these magical abilities, young children are sent to Hogwarts or other wizarding schools across the world to refine their craft.

In this section we'll cover how to hand letter popular spells and potions. We'll also learn how to draw Harry Potter's wand, along with other iconic wands from the movies.

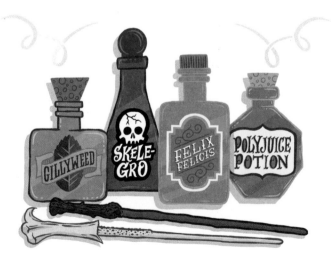

DRAW POPULAR SPELLS & POTIONS

Practice lettering popular spells and potions below. Start with simplified wireframe lettering and gradually build out the thickness of each letterform. Once your lettering is refined, add small details within and/or around each letterform. Finish the lettering by inking and coloring.

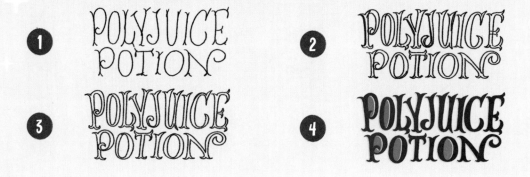

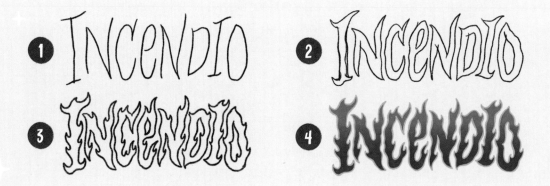

1 *Lumos*

2 *Lumos*

3 *Lumos*

4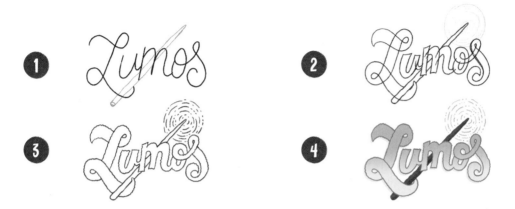

1 STUPEFY

2 STUPEFY

3 STUPEFY

4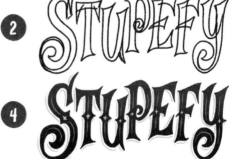

DRAW HARRY POTTER &
LORD VOLDEMORT'S WANDS

Follow the steps below to create Harry Potter's and Lord Voldemort's iconic wands!
Use the blank space on the adjacent page to practice drawing each wand and follow
the same procedure as with the lettering: wireframe, rough sketch, refine, and color.

HARRY POTTER'S WAND

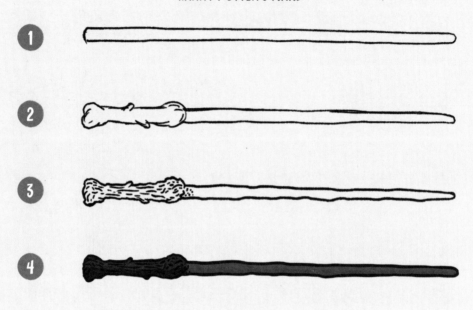

LORD VOLDEMORT'S WAND

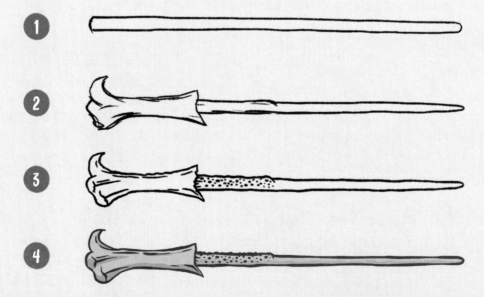

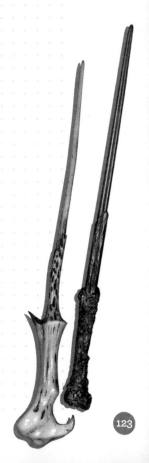

CHARM LETTERING COMPOSITION STEP-BY-STEP

Harry Potter used many different charms. One such charm is *Alohomora*, which is used to unlock windows, doors, and chests—something that has proved to be quite useful throughout the movies. Practice hand lettering the *Alohomora* charm while taking your time to plan and gradually sketch each step from wireframe to colorization, as seen below.

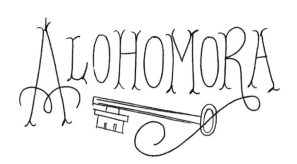

 WIREFRAME

Start with a basic wireframe of the spell's name: *Alohomora*. Work with a sharp split serif and use the tail of the "R" to hold an illustration of a skeleton key.

 ROUGH SKETCH

Roughly start to sketch over your wireframe. Break each character down into a series of shapes. Add sharp split serifs to the tops and bottom of each letterform. Add details to the key and barbs to the crossbars of the "H" and "A."

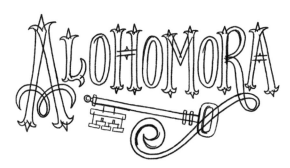

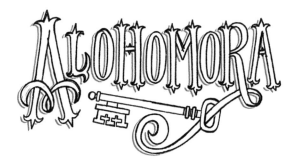

③ REFINE SKETCH

Once the rough sketch composition is in a good place, refine the letterforms and key illustration. Add a thin outline around the letterforms. Clean linework during this step will allow for an easier final step.

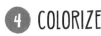 **COLORIZE**

To colorize your artwork, trace over your sketch with ink. Use orange and reds for the lettering and blue for the key illustration and outline. For a nice finished effect, try fading the letters from red at the top to orange at the bottom.

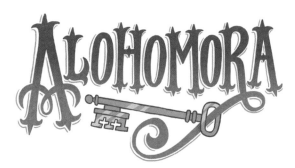

124

POTION LETTERING COMPOSITION STEP-BY-STEP

Drawing potion containers is a fun and easy way to combine simple illustration with hand lettering. Each container is its own piece of art. Feeling overwhelmed by drawing all four potions? Don't sweat it! Start out by creating a single potion, then add the rest when you feel comfortable.

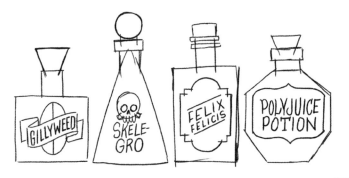

1 WIREFRAME

Each container is basically just a combination of geometric shapes, as seen in the wireframe step below. Draw the containers then the labels. Each label should have a different shape to create range and variation. Add the hand lettering last.

2 ROUGH SKETCH

Roughly start to sketch over your wireframe. Plan out each label's lettering style. Break each character down into a series of shapes and gradually thicken them. Add illustrative details like veins on the Gillyweed leaf, cracks in the Skele-Gro skull, and details on each cork and the *Felix Felicis* cap.

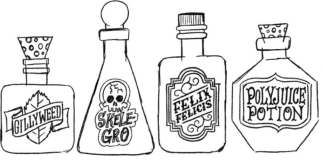

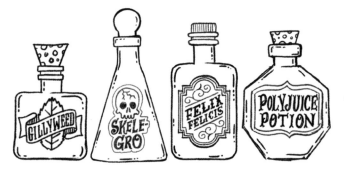

3 REFINE SKETCH

Once the rough sketch composition looks good, refine the container illustrations and hand lettering. Add small lines and dots inside the containers to look like light reflections. Clean up the linework to allow for an easier final colorization step.

4 COLORIZE

To color your artwork, trace over your sketch with ink. Use four different color schemes—one for each potion. Start with lighter colors first, and gradually layer in darker colors. For example, draw the light brown shape of the cork, followed by the darker brown circular details.

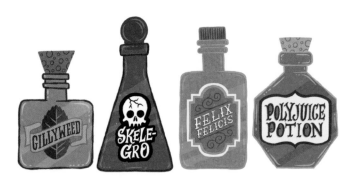

SPELL LETTERING COMPOSITION STEP-BY-STEP

Summoning a Patronus is powerful magic. When Harry yelled out the spell to save Sirius from the Dementors, he conjured a shining stag.

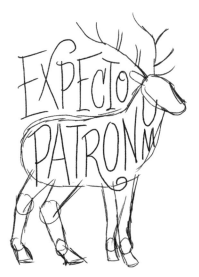

1 WIREFRAME

Start by drawing the loose shape of a stag. Draw the head, the body, and legs as separate shapes. Add wireframe lettering above and inside of the stag's body.

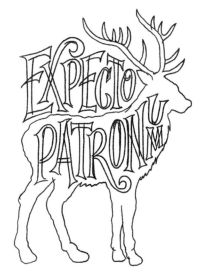

2 ROUGH SKETCH

Build out the thickness of each letter over your wireframe. This is an important step to establish each individual word's lettering style. Note how each letterform is a combination of shapes. Add more definition to the stag shape, like hair and horns.

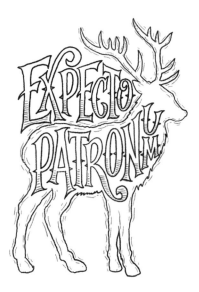

3 REFINE SKETCH

Refine the letterforms by tracing over your rough sketch. Add inner details to the bottom of each letterform. Since this is an illustration of a spell, add small wavy lines around and inside the stag to help give it the impression of being magical.

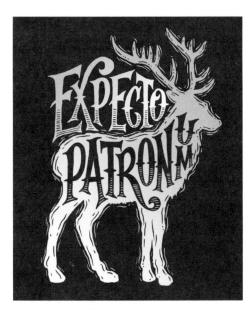

4 COLORIZE

To colorize your artwork, trace over your sketch with ink. In the movies a *Patronus* appears in blue and white tones, so use a similar color scheme in your artwork. A midnight blue background will provide nice contrast against the stag and lettering.

LETTERING COMPOSITION PRACTICE

DRAW YOUR OWN PERSONAL PATRONUS

On page 128 you learned how to draw Harry Potter's *Patronus*. Now it's time to draw your own personal *Patronus*. If you had one, what would it be? Is there an animal that characterizes your personality? I like to lie around and relax in my free time, so a sloth was the obvious choice for me! Check out how I drew my sloth *Patronus* below, but challenge yourself and draw your own on the blank adjacent page.

1 WIREFRAME

Start by drawing the loose shape of whatever animal you choose. Draw the head, the body, and legs as separate shapes. Add wireframe lettering above and below your animal.

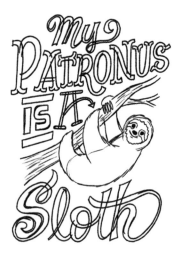

2 ROUGH SKETCH

Build out the thickness of each letter over your wireframe. This is an important step to establish each individual word's lettering style. Note how each letterform is a combination of shapes. Add more definition your *Patronus* illustration.

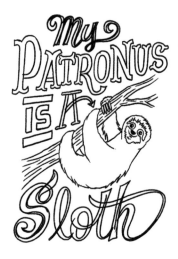

3 REFINE SKETCH

Refine the letterforms by tracing over your rough sketch. Add small wavy lines around your *Patronus* to help give it the appearance of being magical.

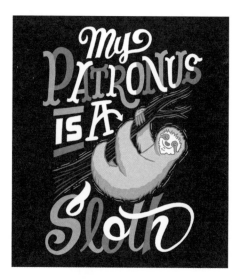

4 COLORIZE

To colorize your artwork, trace over your sketch with ink. In the movies a *Patronus* appears in blue and white tones, so use a similar color scheme in your artwork. A dark-colored background will provide nice contrast.

LETTERING COMPOSITION PRACTICE

CRUCIATUS

INCENDIO

STUPEFY

PETRIFICUS TOTALUS!

AVADA KEDAVRA

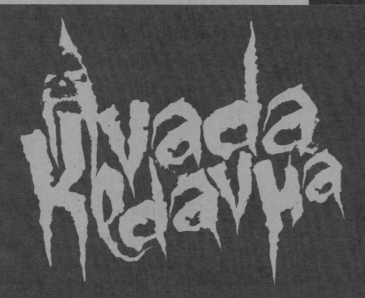
AVADA KEDAVRA

EXPECTO PATRONUM!

INCENDIO

MORSMORDRE

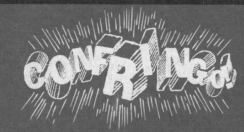
CONFRINGO!

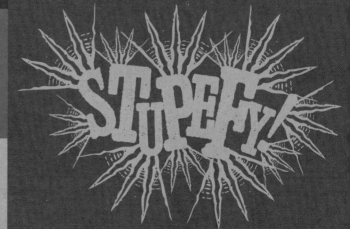
STUPEFY!

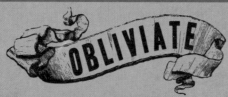
OBLIVIATE

CREATE YOUR OWN SPELL OR POTION

You've hand lettered various spells and potions on pages 124–131, and now it's time to create your very own! What will you call it? How will it be styled? Need a little inspiration? Check out the adjacent page for some great lettering references. Use the space below to execute the steps you've learned to bring your hand-lettering artwork to life — from wireframe to full color!

WANDS FROM THE MOVIES

Harry Potter

Hermione Granger

Ron Weasley

Ginny Weasley

Luna Lovegood

Albus Dumbledore

Minerva McGonagall

Severus Snape

Lord Voldemort

Section 9 | SPELLS & POTIONS

PRACTICE DRAWING WANDS FROM THE MOVIES

In the Harry Potter movies, wands are everything. They can be used to illuminate a room or eliminate an enemy. Witches and wizards are *nothing* without their wands. Try drawing your favorite characters' wands on this page. Start by sketching over the gray wand-like shapes seen below. Can't remember what your favorite characters wand looks like? Check out the wands on the adjacent page. If you still need help, refer to the Harry Potter and Voldemort wand-drawing process we covered on pages 122–123.

Pay attention to the details that define a particular wand. Some wands are rounded and smooth, while others are embellished and ornate. Don't forget to emphasize these characteristics in your art.

Section 10

MAGICAL CREATURES

INTRODUCTION TO
MAGICAL CREATURES

Throughout *the* movies, Harry Potter and his friends come across a wide range of magical creatures during their adventures. Some of these creatures may seem rather ordinary in appearance but at the same time have magical properties & abilities, like Harry's owl Hedwig, who delivers mail *and* can find a recipient regardless of their location. Some of these creatures are strong and imposing, whereas others are cute and funny, but one thing is certain—they are one of *the* most captivating aspects of the wizarding world.

In this section we'll learn to hand letter *and* illustrate popular magical creatures like Thestrals, house-elves, *and* Dementors.

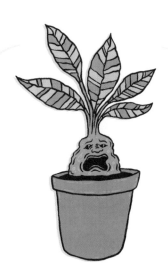

HAND LETTERING CREATURE NAMES

Practice lettering popular creature names below. Start with simplified wireframe lettering and gradually build out the thickness of each letterform. Once your lettering is refined, add small details within and/or around each letterform. Finish the lettering by inking and colorizing.

1 THESTRAL
2 THESTRAL
3 THESTRAL
4 THESTRAL

1 HIPPOGRIFF
2 HIPPOGRIFF
3 HIPPOGRIFF
4 HIPPOGRIFF

① GIANT

② GIANT

③ GIANT

④ GIANT

① CORNISH PIXIES

② CORNISH PIXIES

③ CORNISH PIXIES

④ CORNISH PIXIES

THESTRAL ILLUSTRATION STEP-BY-STEP

Although spooky to look at, Thestrals are kind and gentle but
only visible to those who have been touched by death.

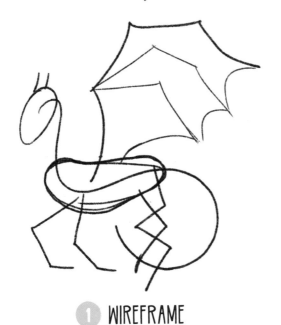

1 WIREFRAME

Start by drawing loose shapes of a head and abdomen. Add
a curved line for the neck, spine, and tail along with wings
and legs. Avoid adding too much detail during this step.

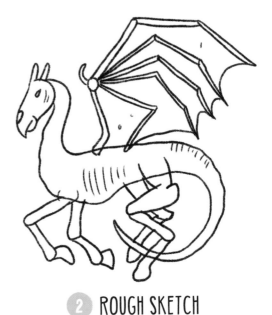

2 ROUGH SKETCH

Using your wireframe as a guide, start by roughly sketching the
shape of an abdomen. From here add legs, wings, and definition
to the Thestral—like horns, ribcage details, eyes, and a mouth.

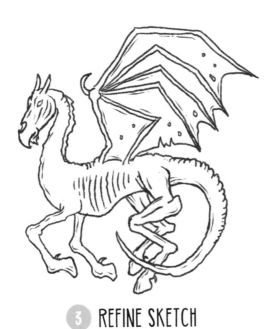

3 REFINE SKETCH

Refine your Thestral by drawing over your rough sketch. Start
with the head and work down. Notice how the linework has a
shaky quality and try to mimic this in your art. Holes and tears in
the wings, along with spikes on the hooves, add a nice touch.

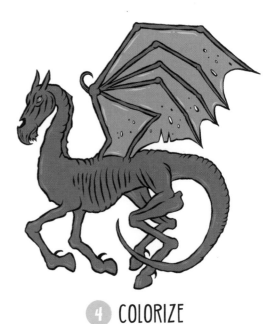

4 COLORIZE

To colorize your artwork, trace over your sketch with black
ink. In the movies, a Thestral appears to be dark gray, so use a
range of gray colors in your artwork to maintain continuity.

 A wireframe is one of the most important steps of the process. A properly planned wireframe will provide a foundation for your finished artwork.

HEDWIG COMPOSITION STEP-BY-STEP

Harry's faithful Snowy Owl Hedwig was an eleventh birthday gift from Hagrid,
who bought her in Diagon Alley as Harry prepared for his first year at Hogwarts.

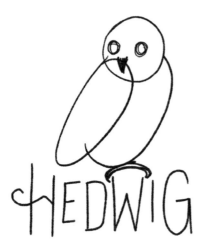

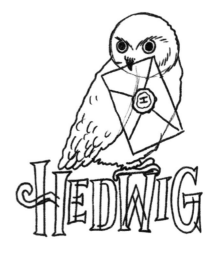

 WIREFRAME

Start by drawing three loose oval shapes, one each for the
head, body, and wing. Under these shapes add wireframe lettering. Link
the two together by adding a curled claw shape above the letter "W."

 ROUGH SKETCH

Build out the thickness of each letter over your wireframe.
Add a rectangular envelope shape to the owl and begin
adding rough details like a beak, feathers, and eyes.

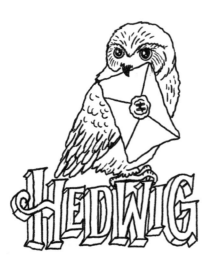

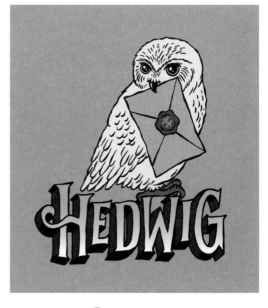

 REFINE SKETCH

Refine the letterforms by tracing over your rough sketch. Add
a dimensional drop shadow to give the lettering depth. Build
on the owl sketch by adding even more feathers. Add two small
white spots to each eye and a Hogwarts' "H" seal to the envelope.

 COLORIZE

To colorize your artwork, trace over your sketch with black
ink. Use a limited color palette of white, red, and gold.
Don't forget add gold color to Hedwig's eyes. A light blue
background provides a nice backdrop for your artwork.

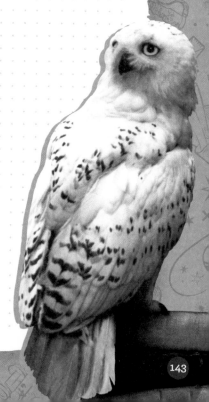

NORWEGIAN RIDGEBACK COMPOSITION STEP-BY-STEP

Norbert is a Norwegian Ridgeback dragon that was raised by Hagrid from a black egg. When it was later discovered she was female, she became Norberta.

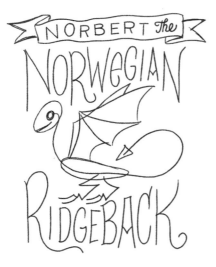

 WIREFRAME

Start by drawing loose shapes of a head and abdomen. Add a curved line for the neck, spine, and tail, along with wings and legs. Once you have the dragon wireframe sketched, add a banner and lettering above and below the dragon.

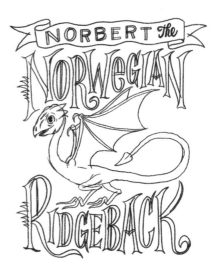

2 ROUGH SKETCH

Using your wireframe as a guide, start by roughly sketching the shape of an abdomen. From here add legs, wings and lastly, details like eyes and a mouth. Build out the thickness of each letter. Add pointy details midway up the stem to the letters "N" and "R."

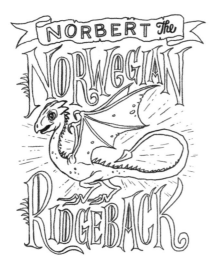

 REFINE SKETCH

Starting with the head, work downward, refining each portion of the dragon. Draw small holes and tears in the wings along with the defining ridgeback spikes along the dragon's spine. Clean up the letterforms and add bursting rays behind the dragon to pull everything together.

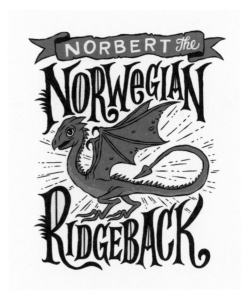

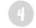 **COLORIZE**

To colorize your artwork, trace over your sketch with ink. Use a brown color palette for the dragon and a slightly lighter brown-colored underbelly. Fill in each counterspace in the lettering with yellow coloring for a fun finished effect.

DOBBY COMPOSITION STEP-BY-STEP

After being freed from servitude in the Malfoy family by Harry's clever sock trick, Dobby joyfully exclaims that he is a free elf.

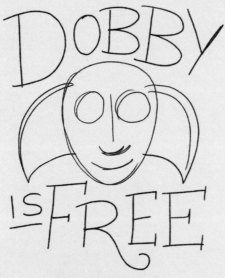

1 WIREFRAME

Start by drawing loose shapes of a head, floppy ears, large eyes, nose, and mouth. Once you have the head wireframe sketched, add lettering above and below.

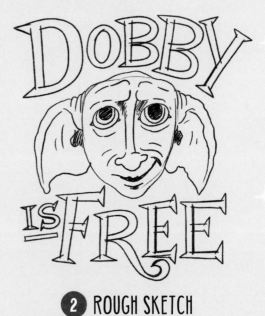

2 ROUGH SKETCH

Using your wireframe as a guide, roughly sketch details like wrinkles and eyes on the head. Build out the thickness of each letterform while adding sharp serifs to the ends of each stroke.

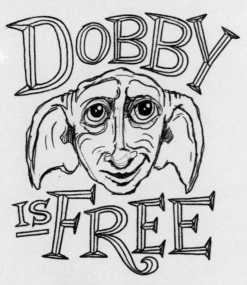

3 REFINE SKETCH

Refine the letterforms by tracing over your rough sketch. Draw inner dimension within the words "Dobby" and "Free." Continue to refine the head illustration by adding more wrinkles and two small white dots on each eye.

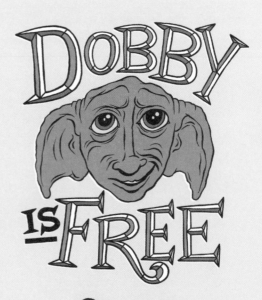

4 COLORIZE

To colorize your artwork, trace over your sketch with ink. In the movies Dobby appears to have flesh tones similar to a human, so use a range of browny-pinks in your art, along with green eyes. For continuity, use the same pink and green shades for the lettering details.

TIP When drawing inner dimension as seen on the adjacent page, think about the various angles light will hit. All of the left-facing portions are one color, versus right-, up- and down-facing portions.

KREACHER COMPOSITION STEP-BY-STEP

Kreacher is tied to Grimmauld Place where he has served the House of Black for generations. He hates Harry but later comes to respect him and rallies the house elves in the final battle against Voldemort at Hogwarts.

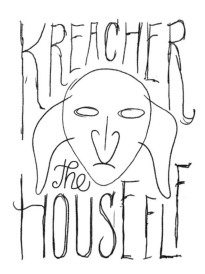

1 WIREFRAME

Start by drawing loose shapes of a head, floppy ears, squinty oval eyes, nose, and frowning mouth. Once you have the head wireframe sketched, add tall lettering above and below to fill in all the space around his head.

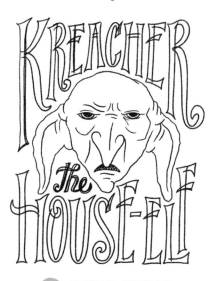

2 ROUGH SKETCH

Using your wireframe as a guide, roughly sketch details like wrinkles and eyes on the head. Build out the thickness of each letterform and add serifs and flourishes to the ends of each stroke.

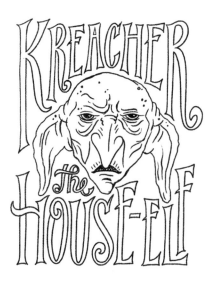

3 REFINE SKETCH

Refine the letterforms by tracing over your rough sketch. Continue to work on the head illustration by adding more wrinkles and dots. The refined sketch should appear to have a scowl, as Kreacher often does throughout the movies.

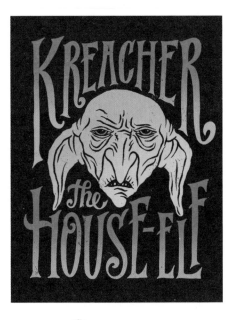

4 COLORIZE

To colorize your artwork, trace over your sketch with ink. Use a range of dull pinks for Kreacher's skin tone, along with pale green eyes. For the lettering, try using a fade from dark to light green. A dark background provides nice contrast to your final artwork.

DEMENTOR COMPOSITION STEP-BY-STEP

Slimy, dark, cold, and terrifying, a Dementor is the most feared creature of all. Get too near one and they suck all of the happy memories and good feelings out of you.

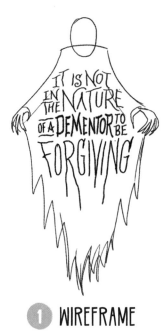

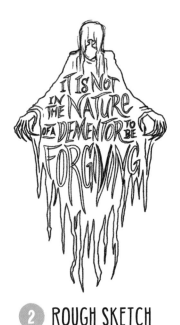

1 WIREFRAME

Begin by drawing an oval-shaped head, shoulders, arms, and tattered robes. Within the shape, add wireframe lettering. Use a range of small and large words to create emphasis and variation.

2 ROUGH SKETCH

Build out the thickness of each letter over your wireframe. This is an important step to establish the lettering style, which has a very sharp and menacing appearance. Draw a hooded-head, long sharp fingers, and tattered robe ends.

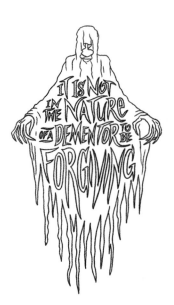

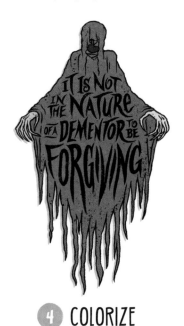

3 REFINE SKETCH

Refine the letterforms by tracing over your rough sketch. Each letterform should have sharp and pointy characteristics. Finalize your sketch by drawing additional creases and details to the robe.

4 COLORIZE

To colorize your artwork, trace over the sketch with ink. In the movies Dementors have dark gray and black robes, so use a similar color scheme in your artwork. Use a cold blue color for the creature's hands.

Section 11

QUIDDITCH

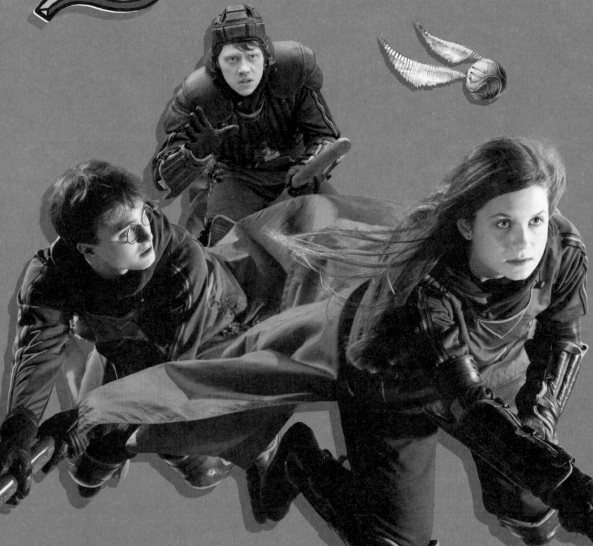

INTRODUCTION TO
QUIDDITCH

Quidditch is the most popular sport among wizards *and* witches and is played regularly throughout *the* movies. The object of the game is to score more points than your opponent by throwing a ball into a goal while flying around a pitch on broomsticks. A game ends when a small golden ball with wings, called the Golden Snitch, is caught. Throughout his time at Hogwarts, Harry Potter was a very successful player *&* managed to catch the Golden Snitch on many occasions. Scoring goals, bludgeoning opponents, and high-speed chases for the Golden Snitch are just a few of *the* reasons why Quidditch is one of the most exhilarating parts of these movies.

In this section you'll learn to hand letter *and* illustrate Quidditch-related art: the Golden Snitch, broomsticks, *and* team badges.

HAND LETTER QUIDDITCH TERMS

Practice lettering Quidditch terms below. Start with simplified wireframe lettering and gradually build out the thickness of each letterform. Once your lettering is refined, add small details within and/or around each letterform. Finish the lettering by inking and coloring.

① KEEPER **②** KEEPER

③ KEEPER **④** **KEEPER**

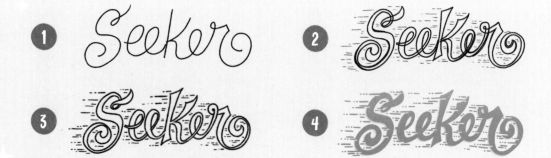

① *Seeker* **②** *Seeker*

③ *Seeker* **④** *Seeker*

1 BLUDGER

2 BLUDGER

3 BLUDGER

4 BLUDGER

1 CHASER

2 CHASER

3 CHASER

4 CHASER

155

DRAW SIMPLE QUIDDITCH ILLUSTRATIONS

Integrating simple illustrative elements around your hand lettering can make a composition more dynamic. Follow the steps below to portray some fun Quidditch icons from the Harry Potter movies. Use the space on the next page to practice drawing each of these pieces.

1 WIREFRAME **2** ROUGH SKETCH **3** REFINE SKETCH **4** COLORIZE

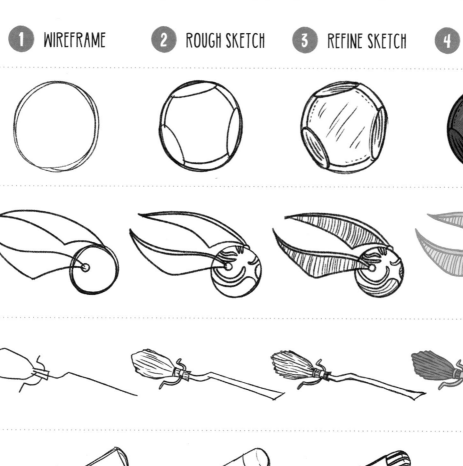

GOLDEN SNITCH COMPOSITION STEP-BY-STEP

In a game of Quidditch, the capture of the Golden Snitch immediately gives 150 points to the victorious seeker's team and wins the game.

1 WIREFRAME

Start by drawing a loose circular shape in the center of your page. Add curved wings and wireframe lettering above and below the snitch. Work your lettering around the Snitch illustration.

2 ROUGH SKETCH

Using your wireframe as a guide, start by roughly sketching in thickness and shape to each letterform. Use three different lettering styles for each of the three words. Add loose ornate detailing to the Snitch illustration.

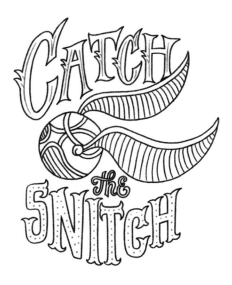

3 REFINE SKETCH

Refine the lettering and snitch illustration by sketching over your rough sketch. Add vertical lines inside the wings and ornate detail to the circular Snitch body. Clean up each of the letterforms and add inner lettering details to the larger top and bottom words.

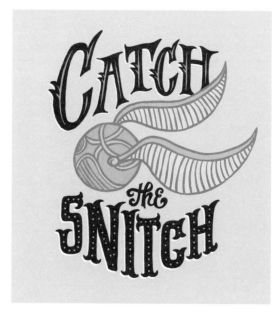

4 COLORIZE

To colorize your artwork, trace over your sketch with ink. Use a range of beige and gold for the Snitch. Dark blue will provide nice contrast for the lettering, with gold inner details to pull it all together. Light blue is perfect for a sky-blue background.

NIMBUS COMPOSITION STEP-BY-STEP

During Harry's first year at Hogwarts, he received a brand-new Nimbus 2000 as a gift from Professor McGonagall, the head of Gryffindor house. The sleek and shiny Nimbus 2000 was the fastest broom in production at that time and easily outperformed its competitors.

1 WIREFRAME

Start by drawing a loose broom shape in the center of your page. Add curvy wireframe lettering above and below the sketched broom.

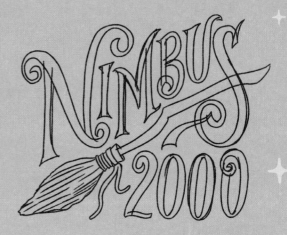

2 ROUGH SKETCH

Using your wireframe as a guide, roughly build out the thickness of each letterform while adding sharp serifs to the ends of each stroke along with flourishes to the ends of some of the strokes, as seen with the letters "S" and "N" above. Add bristles to the bottom of the broom along with footrests.

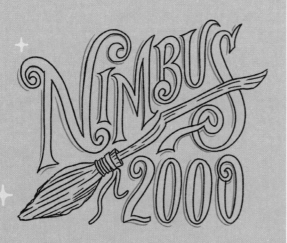

3 REFINE SKETCH

Refine the letterforms by tracing over your rough sketch. Add dimensional outlines around each letterform. Don't forget to draw wood-grain details on the shaft of the broom. Clean linework will make the final step easier.

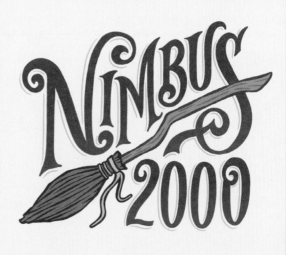

4 COLORIZE

To colorize your artwork, trace over your sketch with ink. Brown and orange work well for the broom coloring, with a deep turquoise for the hand lettering. Try a soft tan background to give the composition plenty of contrast.

 When you're looking to include a central illustration to your composition, I have always found it easiest to draw *the* illustration first *and* add the hand lettering afterward.

QUIDDITCH BADGE COMPOSITION STEP-BY-STEP

Every Quidditch team has a badge or crest adorned to their uniform. These designs typically include a mascot and team colors. Follow the steps below to create a Gryffindor Quidditch badge.

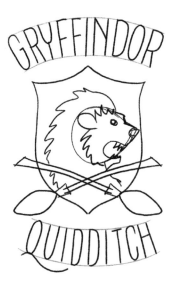

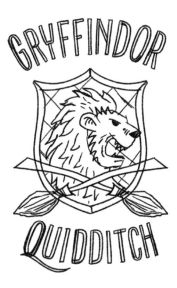

1 WIREFRAME

Start by drawing a crest shape in the center of your page. Within the crest, add a lion's head with some crossed broomsticks. Sketch two arched guides above and below the crest to help with your wireframe lettering.

2 ROUGH SKETCH

Using your wireframe as a guide, roughly sketch details like wrinkles, mane, teeth, and eyes on the lion's head. Add a checkered background to the crest along with an outer frame. Build out the thickness of each condensed letterform.

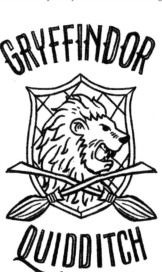

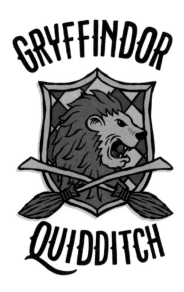

3 REFINE SKETCH

Refine the letterforms by tracing over your rough sketch. Continue to improve the head illustration by adding more mane and other facial details like wrinkles and teeth. The refined lion's head should appear to be growling fiercely.

4 COLORIZE

When you're ready to colorize, trace over the sketch with black ink. Use a Gryffindor-inspired color palette of reds and golds, along with a mixture of brown and beige for the lion's head. For the lettering, use a dark color like black to make sure the badge is legible from a distance on a team jersey.

TIP Practice drawing the same word or letterform in a range of different styles. This can be a great way to push yourself and become a more well-rounded hand-lettering artist.

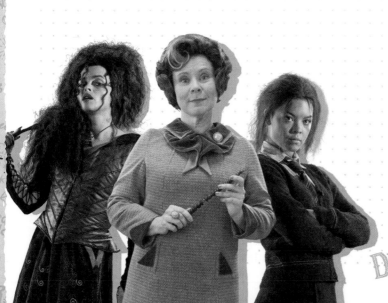

Hogwarts

Blaise Zabini

Incend

TIP Imperfection can add character *and* interest to your lettering artwork. Crooked linework and misaligned letterforms can give your finished artwork a more unique *and* human aesthetic.

POLYJUICE POTION

MUGGLES

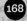168

INCENDIO

Hogwarts

Incendio

Stupefy

TIP Practice drawing one of 🝰 lettering compositions from an earlier page in a completely different style than what is taught. This is a great way to build range 🝰 become a more versatile lettering artist.

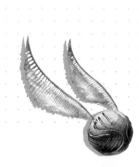

A B C D E F

G H I J K L M

N O P Q R S

T U V W X Y Z

TIP The tiniest details can completely change the appearance of a letter. Experiment by adding different details to the the same letterforms. Notice how different the same letters might look with different details.

GIANT

PRACTICE PAGES

MUGGLES

CORNISH PIXIES

A B C D E F

G H I J K L M

N O P Q R S

T U V W X Y Z

TIP Looking for inspiration? Try watching a Harry Potter film while you practice your lettering & illustration. Aim to fill *the* entire page with creatures, names, quotes, *and* phrases. Have fun with it!

PRACTICE PAGES

RON WEASLEY